painting with *watercolour* CHALLENGE

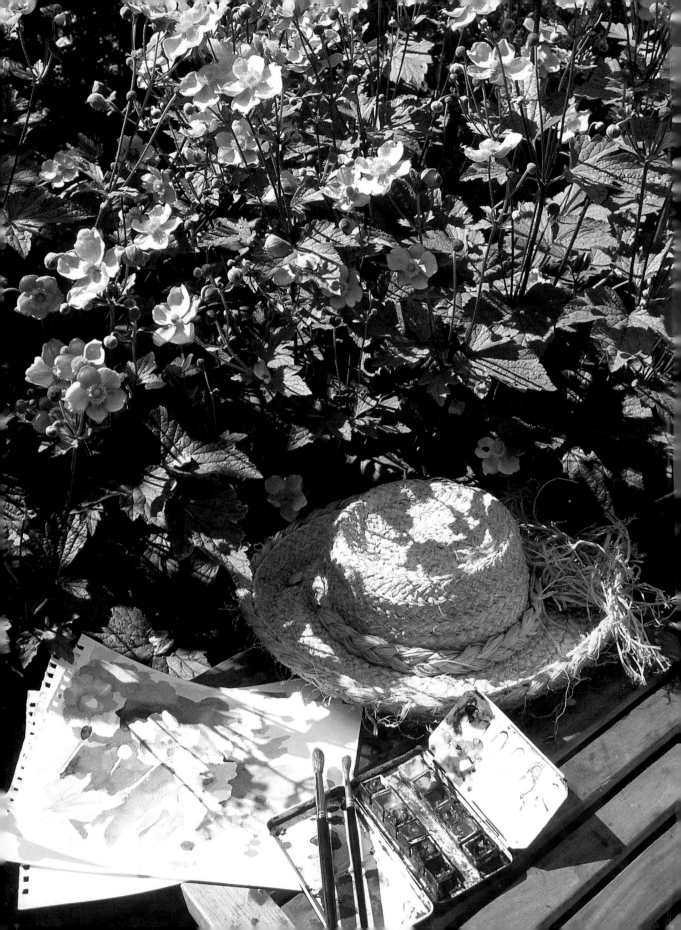

For Marjorie, George, John, Angela and dear B, with much love

First published 2000 by Channel 4 Books
an imprint of Macmillan Publishers Ltd
25 Eccleston Place
London SW1W 9NF
Basingstoke and Oxford

www.macmillan.com

Associated companies throughout the world

ISBN 0 7522 1897 2

9 8 7 6 5 4 3

A CIP catalogue record for this book is available from the British Library.

*Except photographs on pages 144 (bottom) and 147 by Nuni Ryder,
provided by Printwise, and photograph on page 6 by John Stillwell/PA Photos

Designed by Blackjacks
Printed and bound in Italy by New Interlitho

PLANET·24

This book accompanies the television series *Watercolour Challenge*,
made by Planet 24 for Channel 4.
Series Editor: Jill Robinson

Acknowledgements
The author's thanks go to the Planet 24 crew and to Emma Tait, the
commissioning editor, and Verity Willcocks, without whose dedication
and hard work as editor this book could never have met its deadline.

painting with
watercolour
CHALLENGE

DIANA VOWLES

Contents

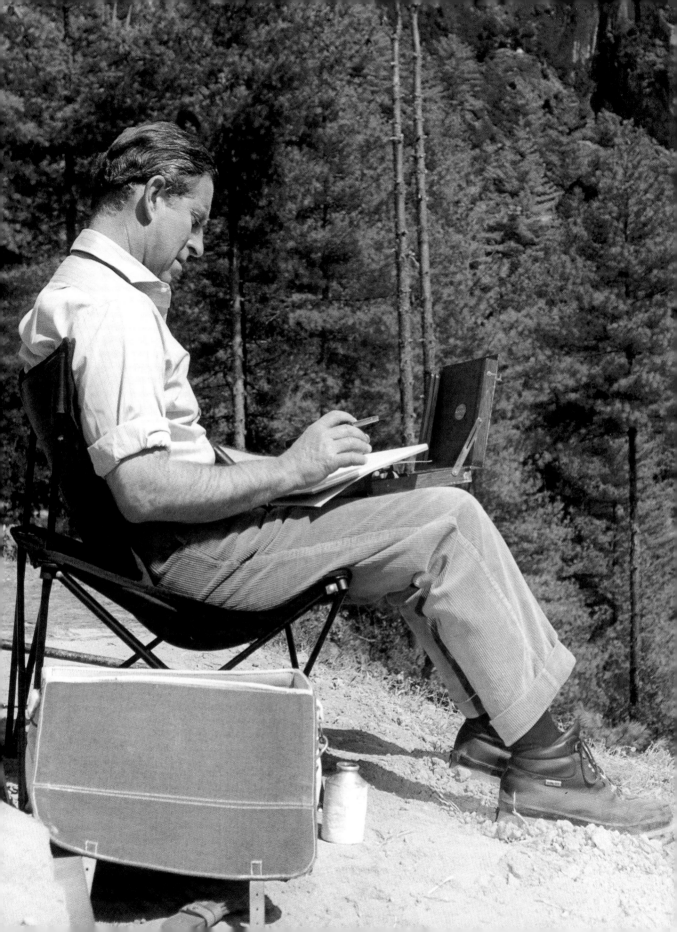

FOREWORD
By His Royal Highness The Prince of Wales

I was very pleased that it was possible for this year's final of *Watercolour Challenge* to take place in the gardens of my home, Highgrove House, in Gloucestershire. Unfortunately, I could not be there, but watched the film – showing the three contestants painting the view along the Thyme Walk towards the house – with great interest. I, myself, have tried to paint this view and find that the cedar tree is one of the most difficult things to capture!

I originally started painting in watercolour because I had an irresistible urge to capture a landscape other than through the agency of a camera. I don't think I have been very successful, but what has always intrigued me is the quality, and indeed, the actual *feeling*, of light. Painting is not just about observation: above all I believe that what you paint has to come from your soul.

I am delighted to have been able to support *Watercolour Challenge* as I feel it gives a real opportunity to promote and encourage budding artists everywhere. I was also particularly pleased that Tom Coates was the professional judge for the final, as I had the pleasure of awarding him The Prince of Wales Award at The Royal Society of Portrait Painters Annual Exhibition earlier this year.

When you work in watercolour you are always learning and developing, and I do not believe it ever gets easier. This is especially apparent if you compare your own work with that of outstanding watercolorists of our time, such as Edward Seago, who was a vital influence in my early years of painting. I have been very fortunate in enjoying the company and friendship of many artists, including several who have accompanied me on official tours abroad. Their encouragement and advice have been invaluable in helping me overcome some of the many technical difficulties involved in using the medium of watercolour.

I do think, as our world advances technically and at such an alarming pace, that there is still a great need for the teaching of drawing and painting, and that these skills remain at the very heart of art and architecture. That is why the Drawing Studio at my Foundation in London's Shoreditch – which has excellent facilities and a full programme of open access art classes – has become so popular with people of all ages. I see this as a way of being able to encourage artists of all abilities and backgrounds, and am delighted that so many have already participated.

Charles

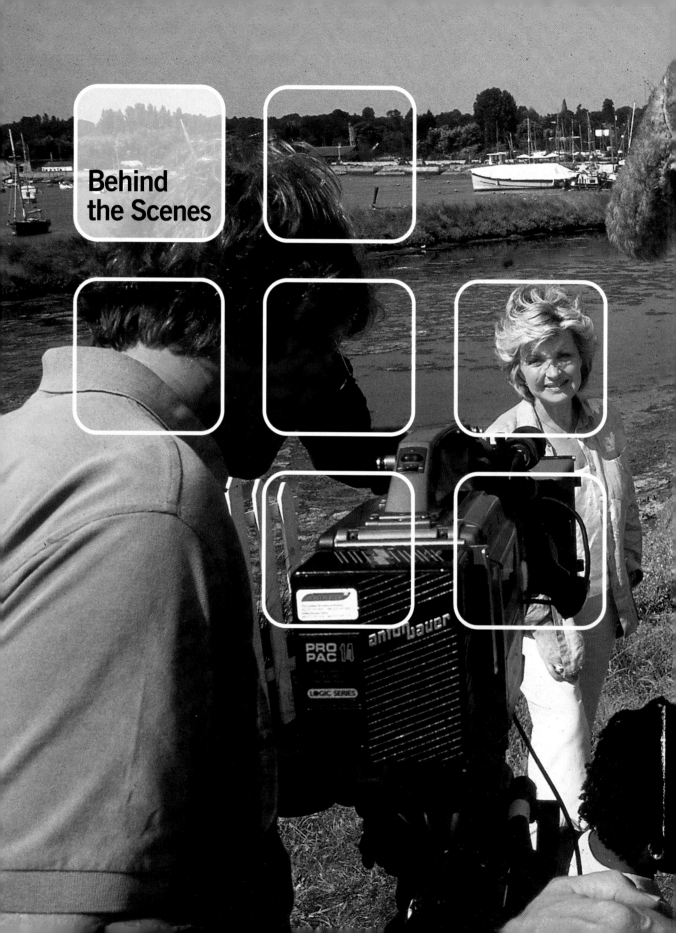

Behind
the Scenes

Watercolour Challenge *is primarily a programme about painting, but it is keyed firmly into the landscape of Britain and Ireland, celebrating its glorious views, its architecture and its history. It is surprising, therefore, that it was born in Los Angeles, the brainchild of Ed Forsdick, now executive producer of Channel 4's morning show* Big Breakfast. *Ed, working in California for the production company Planet 24 and feeling homesick, thought wistfully of England and its tradition of watercolour painting came to mind. He did not know a great deal about the subject, but a search on the Internet filled in some gaps. Planet 24 is known for its unusual concepts and, wondering how artists painting watercolours could make a programme, Ed came up with the idea of introducing a competitive element to what is essentially a peaceful and solitary occupation.*

It was a beautifully simple idea, yet many of the simplest ideas in television are the most difficult to make. The format would have been perfect for a studio, but had to be translated to location shooting. This meant a steep learning curve for the production team as the first series got under way, because they had to tackle the problem of filming three artists and their paintings from start to finish with no leeway for backtracking to fill in any gaps. Experience soon showed that finding suitable locations was going to be trickier than had been envisaged, with the need to ensure there was adequate room for two camera crews to move around the artists and film their view of the location as well as their paintings.

Experience also proved that no stone should be left unturned when reconnoitring the locations. On one occasion the crew reached Yorkshire in a period of particularly bad weather and indoor alternatives had to be found every day as the rain refused to stop. The weather cleared enough one afternoon for the crew to film in their appointed place at an ornamental lake – only to watch a man climb into a boat, row himself out to an island and pull aside some tarpaulin to reveal an electric organ. Some of the more elderly citizens of the town had assembled for their regular two-hour concert, but took it well when the assistant producer was taken out to the organist by pedalo to request a postponement!

However, these small emergencies did not show in the programmes. Crew, contestants and, of course, Hannah Gordon, chosen as presenter for her warm personality and empathy with the artists, all pulled together to make a series of programmes that rapidly built up more than healthy audience figures. Now in its third series and running on well-oiled wheels, Watercolour Challenge *draws its viewers from many sections of the population, from students to retired people.*

Early in the year, an assistant producer sends posters and flyers to art societies, galleries and educational institutions in the regions that *Watercolour Challenge* will be visiting. Spreading the net still further, the programme-makers target architectural, graphic design and jewellery firms, cafés near to galleries and even tattoo parlours in the search for people who might use their artistic talent to paint in their spare time, and a deliberate effort is made to hunt out a wide age range. As the programme has become more established, its makers have realized that semi-professional and professional artists have begun to apply to be on it for the publicity it brings, and at this stage a sharp eye is kept on applications to make sure that only genuine amateur painters get through.

The prospective contestants then send in some samples of their work and a shortlist is drawn up. The assistant producers telephone everyone on that list to check that they will be free not only for the regional week but also for the finals. They then set off to the different regions armed with video cameras and hold a series of auditions lasting for about 30 minutes, during which the contestants are required to do a 15-minute painting sketch of the room or the view out of the window. They are asked at the beginning about what they are hoping to achieve in their paintings and are then interrupted while they work, so that in effect they are put through a mini-version of the programme. Being on *Watercolour Challenge* is no ordinary day's painting. It is essential to find people who are temperamentally suited to it, which means they must be able to talk and paint at the same time and also take a philosophical view of being stopped and started so that the camera teams can get the shots they need. This test piece also shows the assistant producers how the contestant works, so that on the day of the shoot they will know whether they can expect him or her to paint fast with big loose washes, or spend a long time drawing or executing detailed dry brushwork.

Returning to Planet 24 with their filmed interviews, the assistant producers then show all their material to Jill Robinson, the series editor, and the business

THE SERIES EDITOR

Jill Robinson took charge of the programme as it went into its second season. As series editor, it is her job to find the staff for the programme and then direct their work. 'I have to inspire them and make sure that the right organization has been put into place so that they can do their jobs,' she says. 'If there are any difficulties I have to make sure they are being dealt with quickly and effectively so that they don't go on to mar the series. Above all, I am there to maintain standards. I'm the one person who sees the show from the first idea about a location right the way through to the finished programme and I approve all the locations, all the artists, all the cuts, all the edits. The buck stops here!

'We get a large mailbag, and quite often people write to disagree with the judges' choices. I can't change the judging; the experts' decisions are final. However, during the second series we received a lot of letters from viewers who were having difficulty in hearing what the artists were saying because we had put music on the soundtrack. This year we've restructured the team so that we have a sound recordist with the artists all the time, with the result that the sound quality is better and we shan't have to use music for lack of sound effects. It was the response from the viewers that made me look at that problem, so letters can change things. It's important that viewers enjoy all aspects of the programme.'

(above) An apprehensive moment for the contestants in Liverpool as their paintings are lined up ready for the prize-giving.

(below) At Luntley, Eve Smith finds herself the focus of attention from Mike Chaplin, producer Robin Toyne and Hannah.

of mixing and matching begins. Jill and her team try to match the contestants to the kind of location they like to paint, but they also aim to find three contestants each day who are of differing ages and, more importantly, who have different painting styles. As the three contestants will all be painting the same scene, it is vital for the enjoyment of the viewers that they can watch three different paintings developing throughout the day. And there are practical considerations, too: some of the *Watercolour Challenge* locations can be challenging to get to and the contestants are filmed walking to their easels, so if any of them are disabled they will need to be allocated a location that is easily accessible. The fitter ones might find themselves in a breezy spot at the bottom of a winding cliff path!

Ed Forsdick's original concept was of 'a gladiatorial combat', but one of the most notable things about the artists who take part is how uncompetitive they feel towards their fellow contestants. Time and time again they say how much they enjoyed painting in company, and those who do not go through to the finals watch the progress of the painters who beat them on the day with generous interest and goodwill. 'I've competed with myself, not with the other contestants,' is often the comment, or, given the British climate, 'I feel as if I've competed with the weather.'

THE ROLE OF THE ART EXPERTS

As *Watercolour Challenge* has progressed, the art experts have taken a larger role, suggesting at the halfway point how the contestants might address any problems that are arising and offering more comment, both good and bad, about the finished painting. In the first series there was a feeling that it might be unfair to criticize artists who had been courageous enough to paint in such unusual and sometimes unfavourable conditions, but the contestants themselves asked to have the weaker parts in their paintings pointed out. Now the art experts give a more considered judgment about the paintings, and if the contestants don't agree with what is said they are free to argue! This way both the contestants and the viewers learn more about what makes a good painting.

Jill Robinson chooses the experts, and she aims to find artists who have some link with the locations that will be visited. In the second series Kurt Jackson was the expert in his home county of Cornwall, and Susan Webb was brought in to judge the contestants in Ireland. As Kurt was unable to take part in the third series he was replaced by Jenny Wheatley, also from Cornwall and also, like Kurt, an artist with a bold and unconventional use of colour and texture. Hazel Soan was chosen for

THE DIRECTOR

John Williams joined *Watercolour Challenge* for the third series in a dual role, acting as deputy series editor as well as director. Working closely with Hannah to make sure that she is happy with her script and with any extra comments that arise during the day, John spends most of his time with the Camera A team. He says, 'I try to find the best shots to sum up the particular location in which we're working. Since the programme is about art, we like to reflect that in interesting and creative photography. I don't go to the location in advance, but I'm presented with video material or still photographs so I have an idea what it's like – though sometimes I discover that a beautiful view is much further away than I thought! I'm in overall charge of what happens on the location, and that includes making sure we finish on time. We leave the hotels at about 7am, and if one of the teams holds up the other at the end of the day, it's not popular – so the job is about organization of time as well.'

There's not enough time on location for beautification to be a big issue, but hair stylist and makeup artist Kerry Scourfield is on hand to provide some touches here and there.

her use of loose washes and for her special skill at catching action and Mike Chaplin, a great favourite of the viewers, returned for his second season to lend his particular expertise with architectural subjects. Susan Webb, meanwhile, is a more representational artist with a deep love of horses and of the Irish landscape. With these four artists lined up, Jill could ensure that the contestants and viewers alike would benefit from seeing watercolour used in a variety of ways and that the judging would reflect the experts' different tastes.

The judging is the most contentious aspect of the programme, and Jill is aware that each day some viewers will disagree with the results. However, with four judges from different artistic backgrounds and with different styles, she feels that viewers will find one with similar tastes to their own – and judging is, in the end, a matter of taste. When it comes to finals week, the allocation of contestants and judges is worked out to try to give each contestant an encounter with a different expert to the one who picked them in the regional heats.

(above) An artist working in a public place will nearly always attract onlookers. Here Jenny Wheatley carries on regardless in Kingston Parade, Bath.

(below) Meanwhile, the contestants have not only the public to contend with but also the close attention of the TV crew!

With the input of younger painters and less traditional painting styles, some viewers and contestants have expressed concern that *Watercolour Challenge* might abandon the representational watercolour in favour of *avant garde* art. In fact, the majority of the less representational painters are no more *avant garde* than the French Impressionists, who were painting 100 years ago. Although some may interpret the view to make a composition that pleases them and paint it very loosely, no one has done a purely abstract painting – and Jill Robinson is quite definite that no contestant will be invited on to *Watercolour Challenge* to pickle a sheep!

The experts' tips are a popular part of the programme, giving the viewers a chance to learn direct from the professionals. They are usually linked to the location, and the experts, together with the producers, agree in advance what they will be in order to avoid repeating each other. However, if, on the day, the experts want to adapt their tips when they actually see the location or encounter particular weather conditions they will do so, extemporizing as any artist has to do in an unfamiliar landscape.

LOOKING FOR LOCATIONS

At the very beginning of the production process, Jill Robinson consults a map and carves up the country into different regions, eliminating areas that have already been visited. The next step is to plan a route around the country that will allow the *Watercolour Challenge* Winnibago to make its slow progress from one region to another over the weekend without undue strain on Trevor Jackson, its driver. In fact, the Winnibago is a major factor in choosing the locations, because many of the nicest views in the country are not accessible to it. Given that the Winnibago is Hannah's home for the day and is the source of refreshments, too, *Watercolour Challenge* can't go anywhere without it!

With the regions decided upon, it's then a matter of finding locations that will be interesting for the contestants to paint and that also have some artistic, literary or historical connections. As with the choice of contestants and experts, the emphasis is upon providing variety; locations have included a tank museum and an oil refinery as well as stately homes, famous gardens and

THE PRODUCER

The producer's job begins with reconnoitring the locations and working out the logistics of getting the crews to and from them with maximum efficiency. Rosie Bowen-Jones, one of the four producers, says, 'I need everyone to be in good spirits and working at optimum capacity. As the producer I have to think in advance about everything, almost as if I were planning a military operation, and when we're actually on location I have a detailed schedule so that I know what stage of filming we should be at all the time.

'I write the scripts, including the challenge, the tip and the pieces about the location, and I also decide in advance where the challenge and tip are going to be shot by the Camera A team, who move about the location. It has to be out of earshot of the Camera B team, which is recording the artists, though it can't be too far away or the Camera A team would begin to fall behind. But I don't want them to return too soon as it's off-putting for the artists if one crew is standing around waiting for them to finish, so again it's a matter of careful organization.

'The week following location shooting I go into the editing suites, where I work alongside the editors and write voiceover scripts. The next week I go on recces for new locations, the week after that is script writing and then I'm back shooting on location again. It's very hard work, but what I like about this series is that we are filming people doing something they really enjoy – and we're involving them in the making of a programme that could actually lead them somewhere rather than just using them as subject matter.'

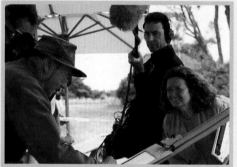

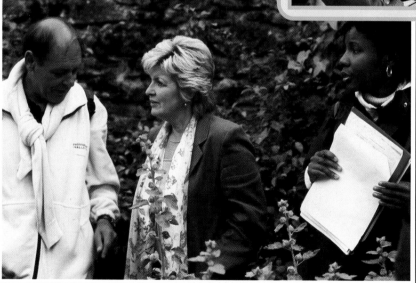

Hannah and John Williams plan the filming of the challenge at Munstead Wood, while location PA Simone Salmon waits poised for action.

some of the most gorgeously rural views in the country. In the third series, Hazel Soan and the team went to an allotment in Surrey to encourage viewers to think about the painting opportunities there might be right outside their own door, while three weeks later Mike Chaplin found himself aloft in a glider in Gloucestershire looking down at three tiny *Watercolour Challenge* umbrellas far below.

Once the question of Winnibago access is resolved, other practicalities have to be considered; a lovely spot may be unusable for a television programme because there is a lot of noise or an ugly background, for example. Also, because the viewers enjoy seeing the locations as well as the

THE ASSISTANT PRODUCER

The main responsibility of the assistant producers, or APs, is to maintain close liaison with the contestants, from initial interviews to the end of their day on location and beyond. At the interview they will familiarize themselves with the contestants' style of painting so that on location they will have a good idea of how fast the paintings will progress and whether there may be unusual techniques that the cameraman should look out for. It is at this stage, too, that the APs establish a rapport with each contestant so that when the interviews are done on location the contestant feels at ease answering the AP's questions.

Amy Walker, one of the four APs, says, 'The crux of my job is making sure that the contestants feel happy with their day and with their painting, taking into account the stopping and starting they have to contend with. Because it's an artificial and unnatural experience they need to be able to feel they can ask me anything, whether it's for a cup of tea or a cigarette break or just what's going to happen next. By the end of the day I feel that I've painted three pictures myself because I've been so gripped by what they're doing. I feel really sorry to see the contestants go, because it is quite an intense and bonding experience – and when the weather is foul I'm just so profoundly grateful that people have kept on going.'

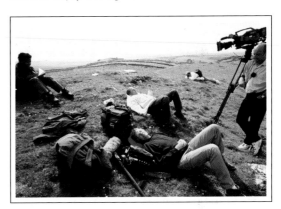

(top right) Ask any of the crew about working on *Watercolour Challenge* and they will stress what hard work it is. However, there is the occasional moment . . .

(right) Jill Robinson, out on location for the day, discusses logistics with Malcolm Gorrie (right) and producer Robin Toyne.

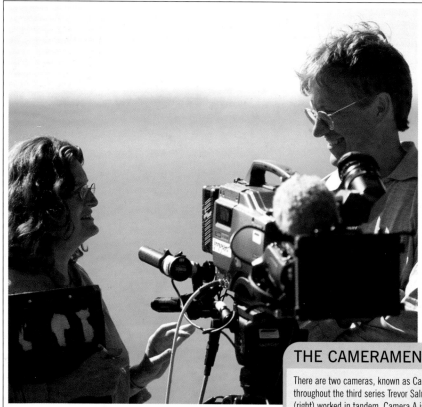

Rosie-Bowen Jones and Trevor Salmon on a sunny day at Lepe, with the blue Solent behind them.

paintings, the team try to pick places that the public can go to see for themselves. All must be within not more than one hour's drive of the crew's base for the week, because each programme must be made in one day – travelling time is time taken away from painting, and the crew, who work long hours day in, day out, need to get back to the hotel in time for a meal and a rest before bed and a 6am alarm call the next morning.

The initial scouting for the locations in the third series was carried out by Rosie Bowen-Jones, one of the programme's producers. After she and Jill had worked out some basic ideas as to where the locations might be, she contacted tourist information bureaux, consulted guide books and researched where artists of the past had painted. She then set off on an initial journey of reconnaissance, starting from a central base and radiating out to find the richest locations in each area.

THE CAMERAMEN

There are two cameras, known as Camera A and Camera B, and throughout the third series Trevor Salmon (left) and Rob Sargent (right) worked in tandem. Camera A is used for filming Hannah and her discussions with the expert, while Camera B remains with the contestants. Camera B is hand-held, so, as the cameras weigh about 27lb (12.2kg), Trevor and Rob take turns week by week to use Camera A, which is on a tripod. Trevor says, 'You get to see more of the location with Camera A, but Camera B allows you to watch the paintings develop. You form quite a close working relationship with the contestants, as you have to monitor the progress of the paintings carefully in case you miss something particularly interesting. It can be hard work, especially in the rain when you're trying to keep both yourself and the camera dry, but we've got such a good team of people that it's fun anyway.' As for Rob, he says, 'The best thing about *Watercolour Challenge* is that it takes me to some lovely places, and I spend the whole of the summer outdoors rather than in a studio.'

THE SOUND RECORDISTS

There are two sound recordists in the crew, one with each cameraman. Hannah, the art expert and the contestants are all fitted with a radio mike hidden under their clothing, but as far as possible interviews are recorded with the boom microphone, or pole, which gives better sound quality. It is the sound recordist's job to decide whether background noise is too intrusive, in which case the piece will be rerecorded if the noise is only transitory. Sometimes, however, a beautiful location may be next to a busy road which the viewers cannot see but would certainly be able to hear, so the soundman will record some 'wild track' of more peaceful sounds that can be found nearby. The wild track can then be laid over the shots instead.

Sound recordist Simon Parmenter (left) explains, 'What we're aiming to do is to give the editors a good choice of sound to select in the cutting room. With two sound recordists using radio mikes and the poles, that gives them four tracks to use. We have to think about what they will need in the cutting room and deliver that in the best and most flexible way that we can.'

Kevin Williams (right), who has worked on all three series of *Watercolour Challenge*, says, 'Because we shoot continually with the contestants we can get problems with background sound that we have to find ways of solving. But it's a good programme to work on – the crew camaraderie is brilliant.'

The first recce is followed by at least two more. The individual producers visit the regions they have been allocated, checking on the finer points of artistic opportunity as well as mundane matters such as toilet facilities, taking in the details of permissions that must be obtained and fees that must be paid as they go. A final recce two weeks before shooting will sometimes throw up unexpected problems, such as a view that was attractive in spring having been completely hidden once the trees are in full summer foliage. Even closer to the shooting date, there can still be hiccups – transport that is intended to play a part in the location may require a repair that cannot be done in time, or the owners of the location may make arrangements for a building job to be done without realizing that the noise will affect filming. But, no matter how frantic the last-minute arrangements, when the week's shooting begins in that region there will be a location organized down to the last detail from Monday to Friday.

Runner Thom Poole spent much of his time on location trying to keep control of the local livestock, in this case a Connemara pony with a taste for the crew's equipment.

Although the artists have four hours in which to paint, the shoot actually lasts for eight hours or more. After an early breakfast at the hotel the crew scramble for the vehicles to reach the location by 8am, and by 8.30am the umbrellas have been put up and everyone is ready to roll.

Once the contestants have been filmed arriving at the location, they take their seats and begin to make decisions about their painting, closely attended by the assistant producer and Camera B team. They will have been warned to bring warm clothes, but for days when things get really tough the crew have blankets, hot water bottles and hand warmers to distribute – and also midge repellent and sunscreen cream for sunnier weather.

Some kind of alternative wet weather location is always arranged, either close by or at a different place entirely. However, as interiors bring problems with sound and light, they are rarely resorted to and the umbrellas are there to provide shelter so that people can carry on painting in the rain. They are very effective against light drizzle, but when there is a real downpour things do become difficult and painting sometimes has to be suspended for a while. Nevertheless, the residents of Britain are not easily defeated by their weather and a spirit of determination prevails. In the third series, this was most notable at Clovelly, where the crew got drenched in an open boat while some visitors from Swedish television stared in wonderment from the windows of the hotel. So bad was the weather that day that a fire was lit in the hotel at lunchtime to try to dry everyone out, and by the end of shooting three months later the name 'Clovelly' was still uttered by the crew in the tones of those looking on past horrors.

While bad weather does take its toll on contestants and crew, the lovelier days are idyllic; the artists get the chance to paint some of the

THE LOCATION COORDINATOR

While the logistics of getting the crew, contestants and art experts to the locations are worked out in advance, seeing that everything goes to plan on the day is a full-time job for the location coordinator. Lunch is usually booked at a pub, café or restaurant nearby, and with more than twenty people to feed, the location coordinator has to make sure that tables are reserved and that the food will be available as quickly as possible. He or she is also responsible for liaising with the local contact about the problems and practicalities of the location, and as these can vary from a bull on the loose to unexpected noise levels a cool head is required.

Malcolm Gorrie, location coordinator on the third series, says, 'At Roundstone in Connemara we found three sets of building works in one small village, and one machine was pounding rock with a noise that echoed right across the harbour. We had to put one of the walkie-talkies in the driver's cab so that we could ask him to stop while we were recording sound. There's what seems almost like a wartime spirit of carrying on in the face of all obstacles, but everyone pitches in and it's good fun.'

A familiar sight on location is that of the crew running for cover as rain threatens, carrying their equipment with them. Here John Williams puts on some speed at Barnsley House to get the judging filmed, with dark clouds looming.

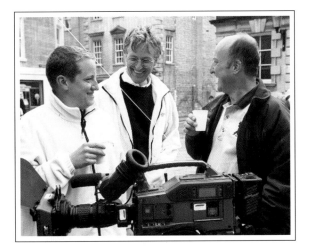

(above) Joe Cooper, Trevor Salmon and Simon Parmenter take a quick break for refreshments in Bath.

(right) In Connemara, midge repellent had to be liberally applied.

(right) Director John Williams discusses the challenge of the day with Hannah and Susan Webb.

most beautiful locations in the country with an assistant producer on hand to supply them with their every need and an art expert to give them some guidance. It's common for contestants to report a dramatic improvement in their work after they have been on *Watercolour Challenge,* as the experience gives a real boost to their artistic ambitions. Although people may feel that they haven't done their best work because of the stopping and starting that is an inescapable part of the filming process, the interruptions are carefully monitored by the assistant producer, who makes sure that everyone gets their four hours, and the crew do try hard not to disturb them at crucial moments. Fortunately, the prevailing feeling among the contestants is that everyone is in the same boat, and the interest of taking part in a television programme is more than adequate compensation.

Once Hannah has been filmed giving the artists the go-ahead to pick up their brushes, work begins in earnest. Hannah and the Camera A team go elsewhere to discuss the challenge with the expert, while Camera B remains trained on the paintings

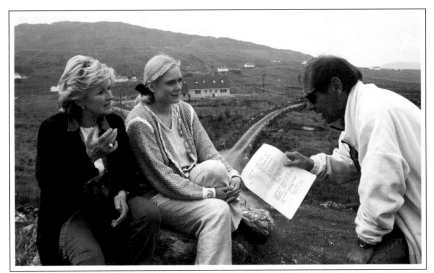

and the assistant producer begins to interview the contestants. Shortly before lunchtime everyone gathers together again so that Hannah and the expert can discuss the paintings at the halfway stage. Then it's off to a nearby pub or restaurant for a hasty lunch before the afternoon's work gets under way, punctuated at tea time with a tray of snacks to keep everyone's spirits up.

As late afternoon moves into early evening, some artists are putting final touches to their pictures and resisting the temptation to overwork them while others are frantically trying to finish before the arrival of the Camera A crew and Hannah's call of 'Brushes down!' Hannah and the expert study the paintings for a final time and retire to discuss the expert's verdict, while the crew set up the paintings on their easels at a judging point where the prizes will be awarded. And then, at the end of a long day, the contestants finally learn who is to go on to the regional final and get the chance of going through to the grand final at the end of the season. It is the special nature of the programme that the winner's success is greeted with enthusiasm by both the crew and their fellow contestants, who have all shared in a day dedicated to three artists' creative response to a subject.

THE TRANSPORT COORDINATOR

Trevor Jackson is often referred to as 'Winnie Trevor', for he is the man who supplies the invaluable Winnibago where Hannah's hair and makeup is done. This tows a trailer, which carries Hannah's wardrobe as well as the props, umbrellas and lighting gear. 'My job is to make sure that the time Hannah spends off set is as relaxing as possible so that she can prepare for the next piece of filming. I think of the Winnibago as her sanctuary,' he says. 'Apart from that, it's a matter of getting the Winnibago and trailer from one location to the next, and that's not always easy because together the vehicles measure 45ft in length and about 9ft across. I have to travel slowly on small country lanes because vehicles can't pass on the other side, so I have to be prepared to stop at a moment's notice. If you find a long queue of traffic in a winding lane it's probably behind the *Watercolour Challenge* Winnibago!'

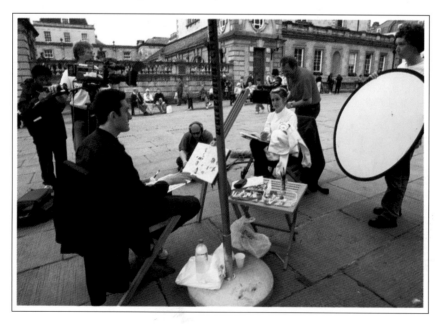

The umbrellas cast shade over the contestants' faces and it is often necessary to hold up a reflector to provide a bit more light for the cameras.

THE POST-PRODUCTION PROCESS ☐☐☐

Post-production is as hectic as the shooting schedule. The weekend after the shoots, the 'online editor' digitizes the tapes from the digital cameras, transferring them to the computers in the three editing suites. On Monday one of the 'offline editors' assembles a tape from everything shot the previous Monday, and the producer comes to the editing suite on Tuesday, having selected the music for all five programmes shot in the past week. During Tuesday a 'rough cut' is made of the first programme and handed to Jill Robinson for checking, while in the second editing suite programme two is being assembled. Wednesday sees the producer hurrying between the first editing suite to do the 'fine cut' of the first programme and the second editing suite to attend to the rough cut of the second. Meanwhile, in the third editing suite, programme three is being assembled ready for the producer's attention the next day. Only ten days are allowed for cutting five programmes, and the producers and Jill Robinson stress how much they rely on the three excellent editors, who all have long experience of the programme. The final touches are done by the online editor, who carefully checks the colour balance of the picture, adds the credits and makes the compilation of shots of the winning artist that follows them. The tape is then sent to Channel 4 for transmission.

Watercolour Challenge is a daytime show with a modest budget but far from modest outlook. To make it happen, all those on board – not least the contestants – have to play their part with determination, good humour and a spirit of adventure. While the word 'challenge' may sometimes seem a little too appropriate on the trickier locations, the beginning of each new series sees the tight-knit crew reassembling full of enthusiasm to meet the amateur artists who take such a professional approach to their role in one of Britain's most popular daytime shows.

(below right) Hierarchy is a low priority on the set and here Jill Robinson is taking a turn with the clapperboard, watched by Hannah, Jenny Wheatley and Felicity Hedley, winner of the 1999 series of *Watercolour Challenge*.

THE RUNNER

Thom Poole, describing his work, says, 'I run about, hence the job title. I get the crew whatever they may need, carry equipment and make sure the public don't gather in front of the camera when we're filming in busy places. Often I have to herd animals away from the set – I've seen off cows, horses and sheep, and at Monnington Court in Herefordshire we had problems with a ferocious black swan! In Bath I had a starring role occupying a bench behind Hannah for 15 minutes, though I think the viewers will see only my shoulder. What I do most of all, though, is supply teas and coffees from thermoses that are filled in the Winnibago. It's a long day and it's vital that people are kept going with snacks, fruit and drinks.'

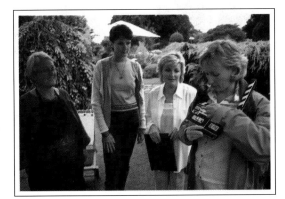

The Experts' Challenge

The art experts who play such a crucial role in the programme are kept busy monitoring the progress of the contestants, discussing the challenge and the tip of the day with Hannah and, of course, doing the judging. Nevertheless, an artist never travels without at least a sketchbook, and in the beautiful locations in which they find themselves the experts always manage to make some time for their own work. While there is no opportunity for a finished painting, pencil and watercolour sketches can be done in between filming and put aside for reference later.

It is these preliminary works that form the basis of the following chapters, with all the wealth of information that they carry. During the third series of Watercolour Challenge the experts were asked to find time to sketch not only for themselves but also for the readers of this book, and to share the thinking process that lay behind their work.

Mike Chaplin, Jenny Wheatley, Susan Webb and Hazel Soan rose magnificently to the challenge. In common with the contestants, they had to make the best of the location in which they found themselves, whether the subject was a favourite one or not – and Mike Chaplin gamely made his first-ever painting of a horse! Some of the sketches they did may go on to become the basis of a finished work, while others may just remain as possible reference material for the future. Each of them a respected artist with an established career, the four experts made the point that all art is a learning process and that no sketch is a waste of time, even if the artist is not happy with it. Their generosity in sharing all their work as they explored the locations is a testament to the desire to communicate a response to a subject that is the starting point for all artists, be they amateur or professional.

Meet the Experts

Mike Chaplin

Mike studied graphics and illustration at Watford Art School in the 1960s. After graduating he gravitated towards printmaking and etching, becoming Vice-President of the Royal Society of Painter-Printmakers. His interest in watercolour developed because in comparison to etching it is so loose and expressive. Mike began to teach art even while he was still at college, and has since taught in youth clubs, in adult education, and at Royal Watercolour Society masterclasses. He sees his role in *Watercolour Challenge* as an extension of that teaching commitment. 'I like to see the way the contestants get more and more taken over by their painting and less aware of the mechanics of filming as the day goes on,' he says.

Jenny Wheatley

After graduating from West Surrey College of Art & Design with a degree in Fine Art/Printmaking in 1981, Jenny painted in Cyprus, the South Pacific and India, where she accompanied a joint British/Indian army expedition in 1987. A member of the Royal Watercolour Society and the New English Art Club, she has taken part in a number of group shows and has had 28 one-person exhibitions. Of *Watercolour Challenge*, she says, 'I think the whole concept is an excellent one because it gives people the opportunity to work under their own steam, but also have some sort of guidance so that they've got something to take away with them.'

Susan Webb

As the daughter of Kenneth Webb, head of the painting school at Belfast School of Art and founder of the Irish School of Landscape Painting in Ashford, Wicklow, Susan learnt how to paint at home. She first exhibited her work when she was only 14 and had the first of her many solo shows in Dublin at the age of 18. She is now principal of the Irish School of Landscape Painting and lectures to art societies in Northern Ireland and the Republic. As a dedicated landscape artist, she says, 'I am glad that the contestants always work on site, even when the weather is poor, as this is really the only way to capture the essence of the scene. I hope that the viewers too will feel inspired to get out there into nature and have a go.'

Hazel Soan

After graduating with a degree in Fine Art, Hazel embarked on a busy career that has encompassed over 20 one-person shows, lectures in Britain and abroad and many contributions to magazines and books. She was the presenter for two series of Anglia Television's *Splash of Colour*, the first series of which was shown on Channel 4 in 1998, and is the author of four books on watercolour, with a fifth, *What Shall I Paint?*, to be published in 2001. She paints extensively in Southern Africa but also maintains a gallery and studio in London. 'More people would paint if they had the time and were not afraid of what others might think,' she says. '*Watercolour Challenge* breaks down both those barriers.'

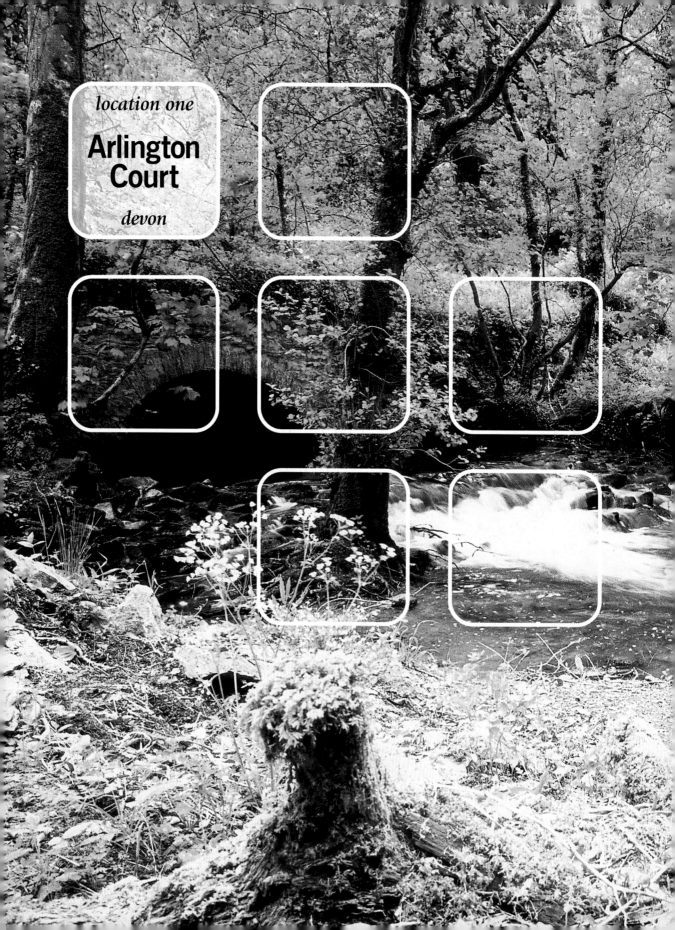

location one

Arlington Court

devon

Arlington Court stands in the densely wooded valley of the River Yeo, not far from the western fringe of Exmoor. The house was built in 1820 by a local architect for Colonel John Chichester and is Greek Revival in style with additions made in 1865 by the Colonel's grandson, Sir Bruce Chichester. It was Sir Bruce's daughter Rosalie, the last member of the family to inhabit the house, who amassed the vast collections that were left to the National Trust, along with the estate, when she died in 1949. They included items as diverse as 200 model ships, 75 cabinets of shells, two cases of candle snuffers, the nose pins of a Solomon Islands chief, a collection of 52,000 stamps and 30 volumes of greetings cards – an unmanageable hoard that was partially dispersed to sale rooms and other National Trust properties. In 1927, an employee listed the Staircase Hall's contents as including a stuffed albatross, a kangaroo and a large bear – an exotic mix even in the days when members of the upper classes, however impoverished, had space to spare and turned to the taxidermist's arts to fill it.

Impoverished (by the standards of her class) Miss Chichester certainly was. Her father left the estate heavily mortgaged when he died in 1881, and it took his widow and only child nearly half a century to pay off his debts. Whether her blighted inheritance was responsible for the lack of suitors or not, Miss Chichester never married and instead threw her considerable energies into politics, astronomy, photography, painting, the social duties of a landowner and, of course, her collections. In 1912, she was joined in her labours by that traditional adjunct of the genteel spinster: a paid companion. Miss Chrissy Peters was a woman of similar ilk, whose capabilities included wiring up the servants' bell system, making crystal wireless sets and painting watercolours, some of which still hang in the house. She remained at Arlington Court until her death in 1939, ten years before the demise of her employer and friend.

So there was already a tradition of art at Arlington Court to encourage the **Watercolour Challenge** contestants when they arrived at the end of May to try their luck at painting against the clock. They were to be set the task of painting not the house and its contents, but the shire horses that are still used for work on the estate. Much of the estate's 1,416 hectares (3,500 acres) is managed with regard for nature conservation, and when the contestants finally reached their location, 800 metres (½ mile) down a muddy drive, they found mature woodland in which decaying trees and logs are left undisturbed to encourage the growth of lichens and provide insect habitats. With a black shire horse, Commodore, tethered to a bush growing on the bridge while his stablemate William hauled tree trunks through the mud, the scene could hardly have been more rural. Imogen Hallam, Lynne Jefferson and Bruce Bond were established under the **Watercolour Challenge** umbrellas right on the bank of the river, looking across to the sun-dappled woods beyond it; a peaceful view that nevertheless posed an unavoidable problem dreaded by many watercolourists – the handling of greens in a landscape.

Lynne Jefferson

Bruce Bond

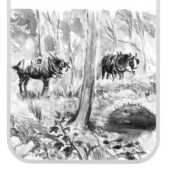

Imogen Hallam

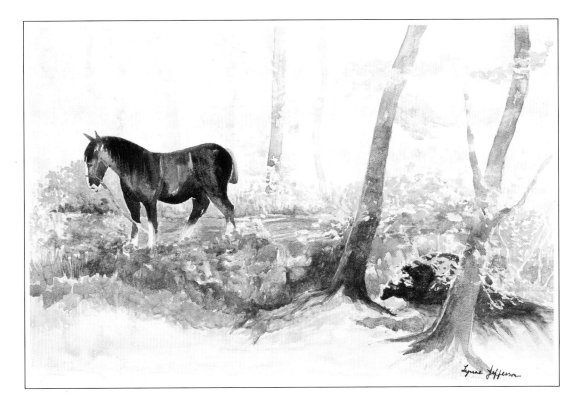

Cool colours and light tones in the background give a sense of distance from the warmer colours in the foreground of Lynne Jefferson's painting.

Lynne Jefferson

A former primary school teacher, now retired, Lynne continues her involvement in education with her role as leader of the Art Group in the University of the Third Age in Plymouth. She has painted all her life, but her interest in watercolour was sparked by a painting holiday just 15 years ago. This turned out to be the first of many painting holidays, and she now belongs to the Plymouth Watercolour Society and the Plympton Painting Group.

After laying soft washes of yellow and blue in the background, Lynne waited until they were nearly dry before she added the tree trunks, giving the effect of soft but not blurred edges. Using a limited palette of only four or five colours, she painted the horse, her focal point, with a mixture of French ultramarine and burnt sienna. As she left the bridge and water until the final stages, she had to put these in quickly, wishing in vain that the four-hour deadline could be extended.

Mike Chaplin gives Lynne some advice on her painting at the halfway stage.

Bruce Bond

Bruce has been painting for 35 years, though it was only 15 years ago that watercolour caught his interest. A retired nurse from the Minehead area, he belongs to the Somerset Society of Artists and the Minehead Painters Group.

Bruce decided to paint the two trees growing by the stream in their exact location, as he liked the way they gave a sequence of frames along the track. He put in a soft background first, painting wet-into-wet and using warmer colours to give the idea of the trees coming forward towards the track where the horse was tethered; then he added the two foreground trees quite strongly, emphasizing the diagonal, because he wanted the whole picture to give the feeling of the horse's momentum towards the right-hand side. The logs on the left-hand side were put in at the last moment with hardly any definition, darker tones indicating their rounded shape. He used a dry brush to give texture to the tree trunks, and in some places applied the paint with the handle of the brush, angling the lines to direct the viewer's eye towards the horse. The diagonals in his painting succeed in giving energy and drama to the scene.

(below) From where the contestants sat it was a peaceful view across the river, but Bruce chose to add some drama.

(bottom) The recurring diagonals in Bruce Bond's painting bring a feeling of nervous energy to the scene.

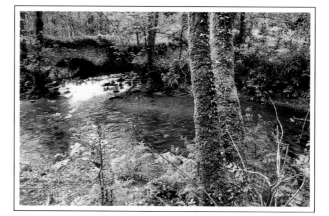

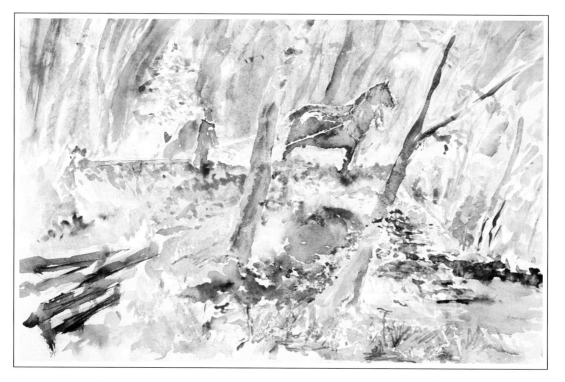

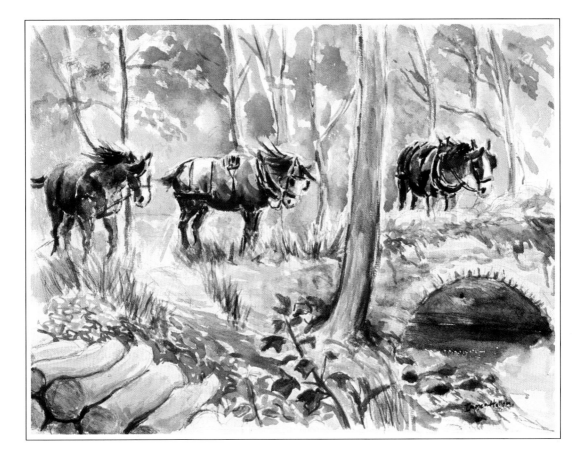

Imogen Hallam capitalized on her interest in horses by painting the real-life model in three different poses, giving her picture a strong narrative element.

Imogen Hallam

Imogen has painted in watercolour since the age of 10 and, after some years spent travelling worldwide, is now studying illustration at Plymouth University in Exeter. This was an ideal location for her, as horses are her favourite subject. Starting with rough sketches, she explored different aspects of the location and how they might interact to form a strong composition. She decided to exclude a big tree that stood on the opposite bank of the river, as she felt that it took up too much of the composition. She also decided to paint three horses, partly because of her fondness for them but also for compositional reasons.

Imogen began her painting process by laying a background wash for the trees, fading them into the distance with blue-greens and introducing warmer colours for the foreground logs and soil, the logs leading the eye into the picture. To show the texture of the foreground grass, she used the paint quite dry and applied it with an old, rather spiky brush. By employing quick brushstrokes and leaving some of the paper white, she gave the impression of light sparkling on the river and introduced a feeling of movement to the water.

THE EXPERT APPROACH

On the morning that the *Watercolour Challenge* team arrived at Arlington Court, rain was lashing down out of a lowering sky, as it had been for the previous three days. The approach to the location, down a winding private road, was now so muddy that trying to reach it without a four-wheel-drive vehicle was thought unwise. Contestants and crew had to be taken down in groups, so, while he waited for some transport tougher than his own car, Mike Chaplin looked for subjects at the magnificent stable block, where 54 historic carriages and six horses are housed.

Crammed with lovingly polished carriagework and harnesses, the stables offered plenty of choice for an artist but Mike, knowing there would be horses at the location itself, decided to sketch Barnaby, a dark bay. He just had time to complete his sketch (see page 37) when transport arrived and he was ferried down to the woodland site where the contestants were already at work. By now the rain had eased off and the day was quite dry and even fitfully sunny, so Mike was able to stroll around the location and size it up without getting soaked.

'This is a difficult subject if you're not a narrative painter, but you could do an expressionist painting full of energy without making it too illustrative,' he said. 'After all, a painting shouldn't be just about narrative, it should be about aesthetics too. Before starting on this, I think it would be a good plan to make some little

(above) Mike and Hannah discuss the challenge of the day at Arlington Court.

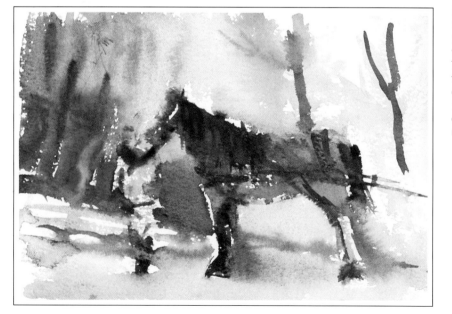

(left) In this five-minute sketch, the darkness of the horse's foreleg contrasts with the light from the sun. The warmth and strength of the colour makes the leg come forward against the more emotionally reserved, cooler colours which recede behind it.

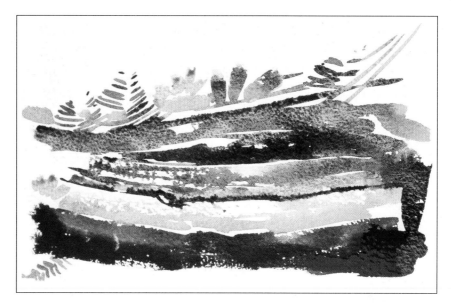

Using rough paper and a No. 10 brush, Mike sketched a log in purple and burnt umber. Quick, short strokes with the point of the brush described the grasses and ferns and located the log within the surrounding landscape.

sketches to try to draw the idea of rhythm. For example, by echoing the curve of the horse's neck as it goes uphill, you could find rhythm throughout the painting that would express the power, energy and movement of the horse.'

In his sketchbook, Mike did a five-minute study of one of the shire horses and its handler, leaving a lot of white paper to give the impression of the dappled sunlight that was now filtering through the trees. 'I'm working very fast to get a broken edge to the subject,' he said. 'If you can use your brush very confidently you can define the shape with the point of the brush and the volume and tone with the belly of it, doing it all with one movement. You could leave a sketch like this as a loose impression, or work any area up into detail. If the painting is to be about light it might be best to leave it as it is, technically unfinished but giving an impression of sun and shade.'

Next, Mike turned his attention to the forest floor, where decaying logs lay scattered among the grasses and ferns. 'It's easy, particularly on an occasion like this when the artists are under pressure of time, to take a wider view and miss the details beneath your feet,' he commented. 'In fact, exploring the textures in a nearby log like this one can help you paint the landscape, as you can borrow from the subtlety of nature. Sometimes the mixtures left in the palette from a previous painting will provide a soft range of colours for a starting point. A sketch such as this takes minimal time, but it can really pay off when you come to paint the whole picture.'

With these two preliminary sketches under his belt, Mike began to formulate some ideas about the wider view. 'In a location such as this you have to make a decision as to whether you are going to tell a story about the horses and woodland or a story about the activity of painting. However, both elements can appear in the same painting, with some areas explained and some merely hinted

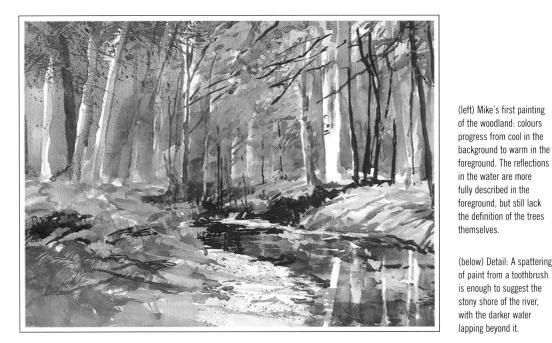

(left) Mike's first painting of the woodland: colours progress from cool in the background to warm in the foreground. The reflections in the water are more fully described in the foreground, but still lack the definition of the trees themselves.

(below) Detail: A spattering of paint from a toothbrush is enough to suggest the stony shore of the river, with the darker water lapping beyond it.

at, playing one against the other,' he explained, cautiously setting up his easel on the driest patch of ground he could find.

Mike's first rendering of the whole scene was concerned with establishing recession, using the principle that warm colours, strong tones and hard edges come forward in a painting while cool colours, light tones and soft edges recede. 'I'm tricking the eye into believing that there is space by manipulating these aesthetic elements,' he said. 'I have also introduced light areas against some of the tree trunks to bring some relief into what is basi-

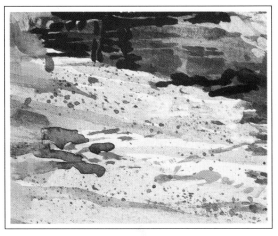

cally a mid-tone composition. In this painting I have made a tentative foray into the paintbox before committing myself to the narrative of the horses. Here I'm dealing just with aesthetics.

'The greens are mixed mainly from blue and burnt umber, which makes a muted olive green rather than a brash green. It also allows me to capitalize on the tonal qualities of the burnt umber in the dark recessive shadows. On the right of the painting the hard-edged lights and darks of the trees transmute into softer-edged shapes in the water, hinting at the difference between reality and its reflection. In the final minutes I spattered paint into the river with a toothbrush to show its stony shore, and added some more spattering to the foliage in the top left of the picture to balance the texture.'

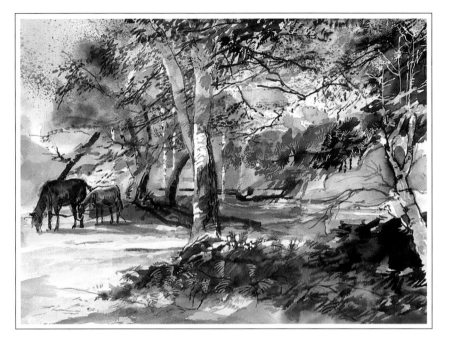

(right) In Mike's last painting of the day the composition is partly reversed, with the warm area now appearing on the left of the picture. With the introduction of the horses, the painting has now taken on a narrative element that is balanced with its aesthetic qualities.

(right) Detail: Here, Mike has counterchanged light branches against dark foliage. This was achieved by a judicious use of masking fluid on top of the initial green washes, put on to preserve the green rather than the white of the paper.

PROJECT

Make a little book of 5 centimetre (2 inch) squares, showing different textures. To do this, lay a paper mask over areas of interesting techniques in paintings you don't want to keep, cut out the squares and staple them together to make yourself a visual dictionary.

The shadows were beginning to lengthen and the three contestants were nearing the end of their work when Mike finally brought together his preliminary studies into a swift painting of the woodland, complete with grazing horses. Although the scene is essentially a peaceful one, he decided to choose a more vigorous composition.

'I have swapped elements of the picture over and placed the warm area to the left rather than the right, so that the viewer encounters it earlier – the eye goes first to where the horses are. The ascending diagonal then leads the eye to some interesting texture. The horses are facing towards the edge of the painting but their heads are down. If they had been staring out of the picture the eye would have followed where they are looking. The ferns are put on with body colour, which gives them a harder look and makes them come forward. The white on the trunks is also body colour – but it might have been better if I had left the white of the paper showing.'

Packing up his painting kit with the satisfaction of knowing that he had accumulated plenty of reference material for use in a finished painting later, Mike then addressed himself to the unenviable task of picking the winner from the three contestants, who were anxiously awaiting his verdict.

PAINTING HORSES

Mike's first piece of advice to an artist embarking upon painting a horse is to try to touch the animal to feel its weight and form, to breathe in its smell and get a sense of its substance and personality.

The drawing stage begins by reducing the horse to very simple geometric dimensions, measuring the proportions of its legs, body, head and neck, and lightly sketching its structure. Mike discovered that the body of his subject fitted into a double square, with the front legs the same length as the depth of the body immediately above them.

Once you have established the correct proportions you can start to refine the shape and show the curves of the real animal, moving towards a drawing that is closer to an anatomical study. As a horse constantly changes its position even when tethered, you will not be able to do a careful slow analysis as you could with a still life subject. Consequently, you may find yourself having to draw the legs or head four or five times in different positions, but as you do so you will learn essential elements of drawing that you can then apply to any horse.

A useful exercise is to spend a day drawing matchstick horses in a sketchbook, trying to capture them accurately from life. Until Eadweard Muybridge took a series of photographs of horses in motion in 1877, no one knew the sequence followed by a horse's legs when it gallops – which is why paintings of horses up to that date show their legs extended back and front like rocking horses. Unless you have a very good eye, taking photographs or even using a video camera are valid steps to learning about an animal's rapid movement as preparations for painting; you can photograph or film particular limbs in movement and make little pencil studies until you feel you understand the horse's anatomy, both when it is still and in motion.

Once you are satisfied with the linear element, you can begin painting to express the volume and form of the horse. Test out colour and the different tones available in it on a small area of the horse first to explore the subtle shadows that indicate the muscular form beneath the skin. The proportions of the horse will inform the viewer whether it is a hack, a thoroughbred or a shire, and your treatment of its coat will allow you to make a final indication as to whether it is a glossy, highly groomed aristocrat of the equine world or perhaps a heavy workhorse that lives outside in all weathers.

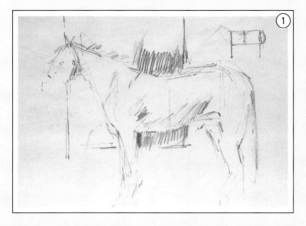

1 Mike's first step was to make a small geometric pencil drawing of Barnaby at the top right-hand corner of a page in his sketchbook. Having established the horse's dimensions, he drew a more realistic sketch.

2 Next, he made a sketch with very weak burnt sienna on watercolour paper. For this he used a No. 8 rigger, which produces a fluid line and holds enough paint to allow the artist to sketch without constant interruption. He also began putting in the dark blue stable door behind, using indigo that would recede against the warm brown he would use for the horse.

3 On a small area of the horse's shoulder, Mike began to explore the colours and tones that he would use to describe the form and volume of the whole body.

4 Completing his sketch, Mike used a moistened brush to lift out highlights on Barnaby's glossy coat and briefly indicated the stable walls and floor to locate him within his surroundings.

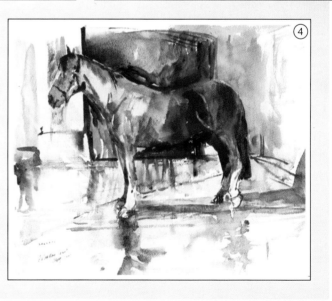

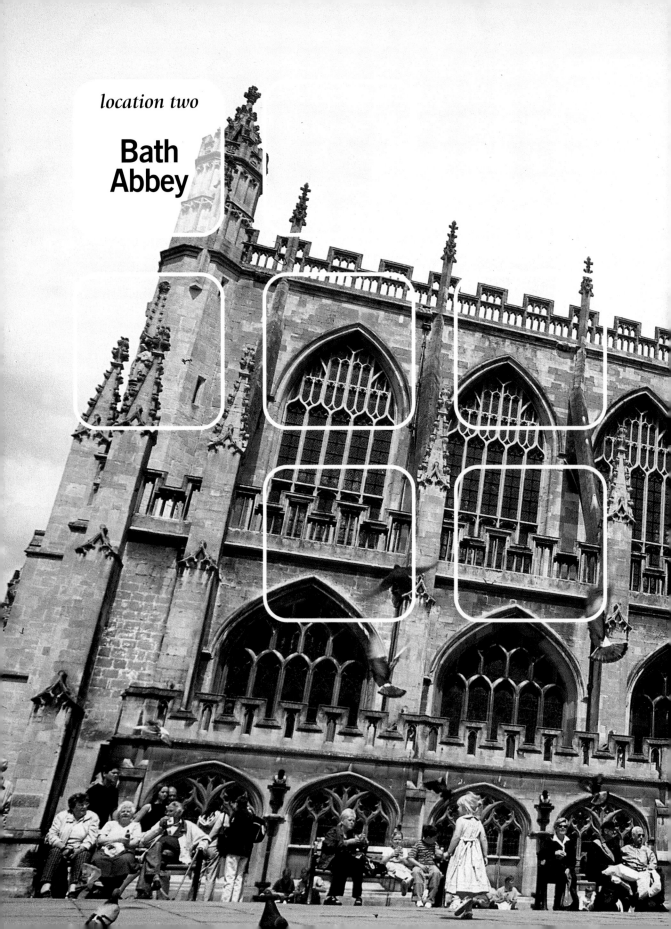

location two

Bath
Abbey

The city of Bath has had not one but two golden eras. When the Romans arrived in Britain in AD43 they discovered a hot spring in the Avon valley, which the Celtic Dobunni tribe believed to be the sacred spring of the god Sulis. The Romans proceeded to apply their engineering efficiency to turning the spring into a curative establishment as well as a place of worship (now to their god Minerva): they built a lead-lined reservoir to enclose the water, a temple and the Great Bath, which was fed from the spring through a lead box culvert and was lined with no fewer than 45 sheets of Mendip lead to prevent ground water from cooling the bath.

The Romans modified and expanded the baths over three centuries, but after the fall of the Roman Empire the city lost its pre-eminence. By medieval times, despite prosperity derived from the wool trade, Bath was considered to be lacking in even the rudimentary sanitation that was then available, and the baths had become dirty and little more than a venue for bawdy behaviour. But in the 18th century, the city was transformed into Britain's most fashionable and elegant resort by three men: Ralph Allen, John Wood and Beau Nash. With Allen providing much of the financial impetus, Wood as architect and Nash as the arbiter of the social calendar, Bath became the place for the fashionable to be seen, where a sense of prestige could be coupled with the comforting idea that the water from the hot spring was actually good for one's health.

The site of the Abbey has been used for Christian worship since AD676, and Edgar, the first king to rule the whole of England, was crowned in the Saxon building of the time. This fell into ruin and work began on the present building in 1499. It was still unfinished when Queen Elizabeth I visited Bath in the 16th century, and she was so dismayed at the sight that she ordered collections to be made throughout the kingdom for the next seven years to raise sufficient funds for its completion. However, it was the Victorians who added the stone fan vaulting that had been planned 350 years earlier, putting the final touches to one of the last great churches to be built in the Perpendicular English Gothic architectural style.

The annual Bath International Music Festival was in full swing when Watercolour Challenge came to town, with classical, jazz, contemporary and world music events on offer. Alongside it runs the Fringe Festival, which provides comedy, art, music, theatre and street performers to further enliven the modern-day city in late spring. With a fire-juggling unicyclist, a balloon artist and a living statue in front of their astonished gaze, the contestants faced the challenge of capturing unfamiliar and very lively activity as well as imposing architecture from an earlier era.

Anthony Price

Marilyn Allis

Robert Newcombe

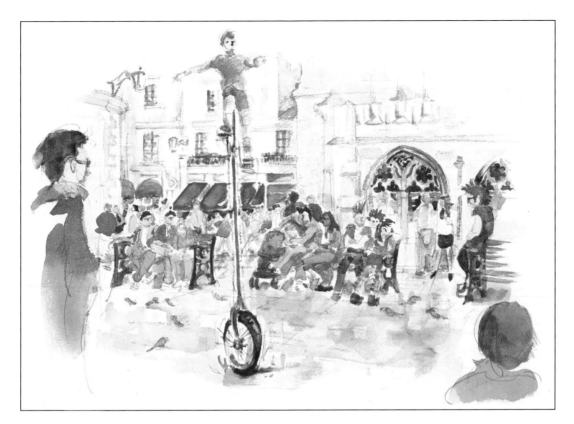

Anthony's painting shows a busy square, with crowds attracted by the activity of street performers. His use of colour adds to the liveliness of the scene.

Anthony Price

Anthony studied Illustration at Plymouth University and won first prize in the Working/Preliminary Drawings category of the Barclaycard Annual Drawing Competition 2000. He has been painting in watercolour for five years, and as he enjoys subjects with plenty of activity and narrative interest the scene in front of the Abbey was very much to his taste.

There was a constant procession of people walking to and fro between the Roman Baths Museum and the Abbey, so Anthony decided to make that area a major part of his painting. He made preliminary sketches of the buildings and of the street performers, then began on his composition, populating the benches in the parade with a selection of tourists. Feeling he was too close to the Abbey to show its perspective, he varied the size of the people instead to give some depth. Once he had laid on colour he decided that his initial pencil work was now more or less lost, so he used pencil once more to regain the architectural detail of the buildings.

Marilyn Allis

As she usually works from photographs in the three years she has been a water-colourist, painting on location presented a real challenge for Marilyn, who is a Deputy Superintendent Registrar. However, she likes to capture movement and energy, so the lively scene of street performers and bustling crowds was not a daunting one. She decided to make the Abbey only a small presence in her picture, instead concentrating on the passageway through to the white building beyond.

Before she picked up a brush, Marilyn did a number of sketches to establish the perspective of the buildings and their proportion to the people. She began by painting in the sky, the distant buildings and the paved ground in loose washes of cobalt blue and raw sienna. Once these were dry she put in the architectural details, working wet-into-wet in the background so that the colours merged softly, but giving more definition to the foreground buildings and figures to give a sense of depth. This recession was enhanced by the use of red for the window boxes and the foreground figure, and cool blues for the crowds at the rear of the passageway.

(above) A ring of benches surrounded the contestants, giving the public plenty of opportunity to watch their activities.

(left) Cool blues in the background of Marilyn's painting and warm colours in the foreground give a feeling of recession to her view through the passageway between the Abbey and the Roman Baths Museum.

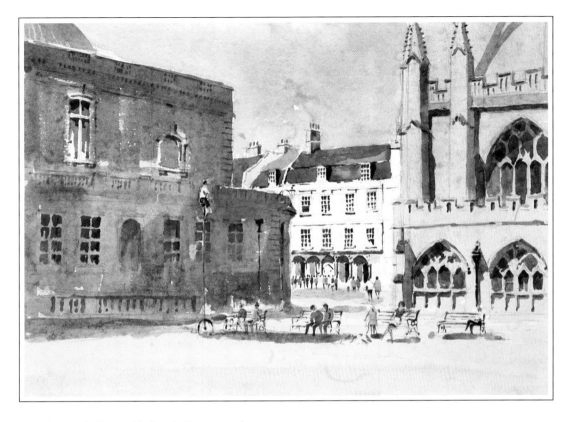

Robert Newcombe

Robert chose to make his painting about the buildings rather than the people. The figures that are present are used to lead the viewer's eye to the white building in the background.

Robert trained to be an architect and worked in the construction industry before taking up a post at Reading University, so a location where buildings played a major part suited him well. Before beginning work on his painting he did a panoramic sketch across both pages of his sketchbook to take in as much of the scene as possible, then decided to arrange his composition so that the viewer's eye would be drawn through to the white building in the background. He did quite a detailed drawing on his watercolour paper before beginning the painting process, placing the people on the benches and in the background at this early stage. After laying initial washes of cobalt blue, raw sienna and burnt umber over the whole painting apart from the white building, he began work with a smaller brush and darker colours to build up detail.

Robert left the shadows until the final stages, by which time the sun had moved round and the Roman Baths Museum, which had been in full sun when he did his original sketch, was now in total shadow. He seized the opportunity to put a darker wash over the Museum, thus throwing the white building into starker contrast. The red canopies on this building also serve to draw the viewer's eye to the focal point.

THE EXPERT APPROACH

The early morning sun was already hot when Jenny Wheatley arrived at the Abbey, dressed in summer colours and equipped with a straw hat to shield her eyes from the glare. 'I thought I would take a look at the view the contestants are painting before they get busy, so that I can think about the problems they may face and how I would tackle them,' she said. After having a quick look around the location, she seated herself directly behind their chairs so that her view was interrupted by the *Watercolour Challenge* umbrellas. Here she did a couple of swift water-

colour sketches in monochrome before the contestants took up their places and the crew gathered around them. She then decamped to a café table round the corner in Abbey Churchyard where, seated in the shade and with a cup of coffee in front of her, she discussed the thinking that had gone into her work so far.

'I have cheated – I wanted to see what the contestants would do but I also wanted to include the brollies,' she explained. 'It's a complicated scene and the temptation is to get it all in, but it's easier to focus on small, personal architectural details, just as you would if you were walking along. I did a drawing first but it didn't go too well, so then I did washes, using paint mixed from a mauve and a brown to make something neutral and cool to establish the tone more quickly than is possible with a pencil. I started from the broader washes and then worked down to the more specific details.

'I knew I was going to get moved on, so I just wanted a note of the shadow round the building in the second sketch. I like little views through because I find

In her first exploration of Abbey Square, Jenny used a neutral colour to produce a swift tonal sketch.

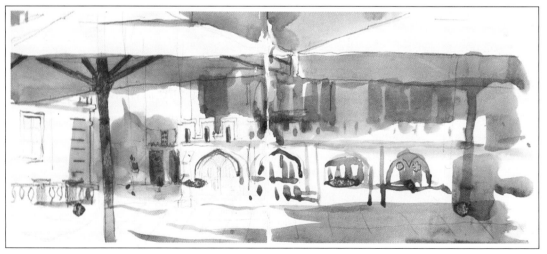

them very theatrical, so I looked into the passageway and also the Abbey window, just feeling the way, thinking about how to put in enough detail to hold it together without being too specific. The trouble with adding too much detail when you start to look into an area is that you can then be loath to get rid of your work if you have got the general proportions and form wrong.

'The contestants will need to be careful if they choose just part of the architecture here. It's easy to get the proportion of a whole building right, but if you are doing only part of it you can go wrong because you are looking at something your eye is not used to seeing in isolation.'

It was now nearly 10 o'clock and the west face of the Abbey, which Jenny was contemplating from her new vantage point, was deep in shadow. As she waited for the sun to reach it, she continued to work in her sketchbook, this time using a soft Black Beauty pencil. 'With this I can make a delicate pencil mark or a thick, heavy line that is almost like using a brush,' she said. 'On the left of the Abbey I have spotted an unexpected view of the landscape with a little statue in front. While the people

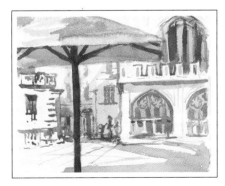

Here the view is narrowed and the passageway has assumed a more dominant role. Detail is beginning to appear here and in the Abbey window.

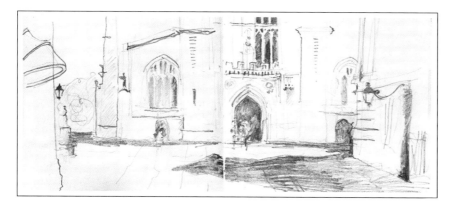

A sketch done with a soft pencil allowed Jenny to put in architectural details such as the lamps, but also to indicate tonal qualities such as the shadow thrown by the Roman Baths Museum.

here are moving back and forth, the solid statue interrupts the view and is silhouetted against the softness of the landscape. I like it, and it stops the eye disappearing out of the picture, too.

'A drawing is only there as a guide to watercolour – you mustn't be a slave to filling it all in. It's like a scaffolding to hang things on, there to be ignored or destroyed later on, but also there to be referred to when you need it. You can take bits in or leave them out, come back to it or not as you feel like it. I'm now going to put some paint on this drawing, and although the Abbey is all in shadow, some parts of the façade will be darker and cooler than others to create the form.'

This done, Jenny walked round to Kingston Parade to discuss the challenge of the day with Hannah and to take a look at how the contestants were progressing. By the time she returned, the light was creeping round and she decided to try a different approach to the Abbey.

'I assumed the Abbey was a long, tall building, but when I measured it for the earlier sketches I discovered that in fact it is almost square,' she said. 'If you have a lot of vertical marks, like the tall verticals of the window, it gives the illusion that the subject is tall and thin. I'm going to do another sketch where I shall

Using warm and cool colours, Jenny put in washes of paint that would act as a reference if she decided to make a finished painting of the scene later on.

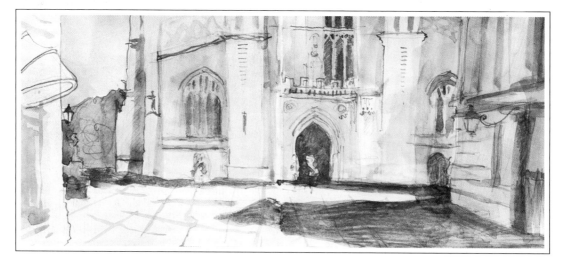

make it much longer and thinner than it really is, just to see what happens – all painting is a learning process, no matter how long you have been an artist.'

Picking up her big sketchbook and a mop brush that would contain a lot of paint but would still come to a point, Jenny set to work. 'I'm plotting it out in a cool wash, blocking in areas and drawing at the same time to try to make sense of it. People are scared of watercolour not being movable, but a sketch like this can be moved and changed as much as you like. You can find your way across the whole painting, balancing tones, colours and shapes, keeping your options open all the way through.

'I'm putting in some yellow higher up in the building, over the arch and on the right-hand side. A greeny yellow wash on one side and darker mauve-blue on the other has now created the pillar to the right of the door by inference – there was no need to draw the pillar itself. As I work, the strong mauve brush-strokes at the top right are being knocked back by the yellow wash going over

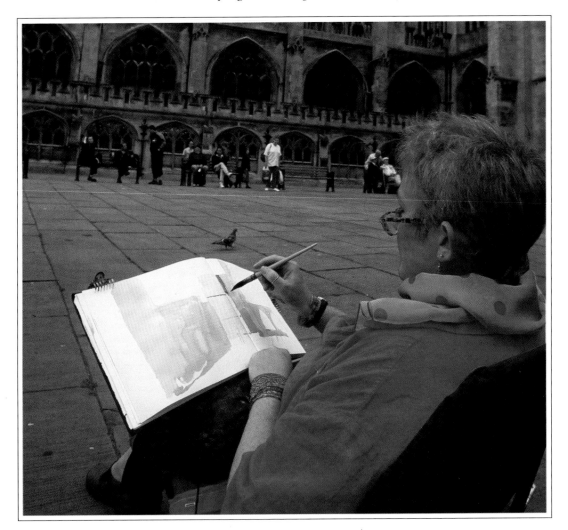

them. The yellow is neutralizing the mauve because they are opposites on the colour wheel, and all opposites lead to grey.'

The day was wearing on and the café tables were filling up for lunchtime. Jenny packed away her materials and vacated her chair, with several sketches in the bag for later reference. It was time to give the contestants some halfway hints before the *Watercolour Challenge* team also broke for refreshment.

In the afternoon, Jenny returned to Kingston Parade, where her day had begun, having had plenty of time to formulate her thoughts about the architecture and what interested her most. This turned out to be the house built in about 1720 by Field Marshal Wade, who had been sent to Bath to subdue Jacobite uprisings and subsequently became the city's MP four times, as well as father-in-law to Ralph Allen.

On this watercolour sketch, the pillar to the right of the door is given form in a matter of seconds by a darker tone of mauve-blue on one side and a yellow wash on the other.

'Although I'm faced with the huge Abbey, I like the flat, theatrical façade of Field Marshal Wade's house through the passageway because it is so ornate and rather quirky,' she said. 'I'll cut off the Abbey not far above the chimney of the flat-faced building next door – this painting isn't about the Abbey and it is simply too high. I'll aim to bring out the central building by using colour and contrast, with dark blocks either side.'

An air of deep concentration emanated from both the contestants and the expert as they worked away in the hot afternoon sun. The benches in the square

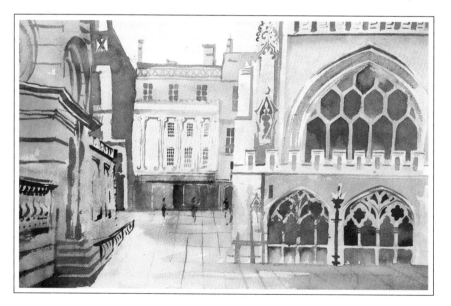

In Jenny's initial painting of her chosen subject, the colours lack the warmth she wanted and the focal point of the rear building is not sufficiently differentiated from the Abbey and Roman Baths Museum.

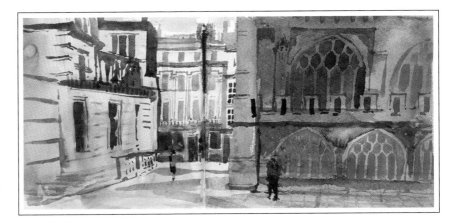

Here the palette is warmer, and the focal point has been separated from the rest of the painting in terms of colour and tone.

were by now filled with watchers, many of them determined to sit it out to see who would win that day. The expert, however, didn't feel she was winning her own personal contest with the subject.

'I wanted to keep it soft and delicate but the overall feeling should be more glowing than it is in my first painting, which is done in yellows and greens. In a second painting, I have separated the Wade house from the rest of the painting in terms of colour and tone, and led the eye through with the shadow. The Abbey is no longer a focus; the planes have been separated and are no longer fighting with each other.

'The painting is still not working, though – it looks a bit chunky, so I abandoned the idea of a long, thin composition and did another drawing in which I extended the foreground so the eye goes in through the passageway to the Wade house. I've done some colour notes, and now that I'm happy with the composition I've got the basis for a finished painting, in which I'll use more orange, pink and yellow to give it a poetic, whimsical colour range with a sunny, artificial effect. At the moment the Wade house has been separated from the Museum and

In this sketch the foreground has been extended so that the eye goes through the passageway to the building chosen as the focal point. The Roman Baths Museum and the Abbey now play a smaller part in the picture.

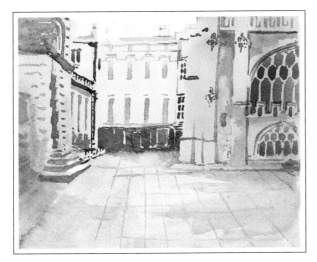

the Abbey with different colours, but I'll try to separate it with line and detail. I'll leave the foreground almost completely blank, with the direction of the marks of the paint leading the eye in.

'Each preliminary study I do is simpler and more specific than the last. My finished pictures might look spontaneous, but a huge amount of work has been done before,' were Jenny's final words as she packed her painting kit away for the day. 'The less you eventually have in the painting the better, but it takes time to achieve that.'

technique

ESTABLISHING A COMPOSITION

When you are faced with an architectural subject such as the contestants found in Bath, it is easy to be so daunted by scale and perspective that it is hard to establish the good composition that is a necessary basis of a successful painting. The answer is to make a series of preliminary sketches until you feel you have explored a number of possibilities and arrived at the best choice.

In contrast to the *Watercolour Challenge* contestants who are under the pressure of the four-hour time limit, the artist working in solitude can devote as much time as is needed to this first stage of the painting. It is well worth doing so, because once you have put some work in on a picture you may be reluctant to scrap it even if you are beginning to suffer from a suspicion that it may be compositionally poor.

A building of such immense solidity and antiquity as the Abbey may tempt you to think that you must paint it accurately. However, as an artist you are just as free to make your own interpretation of it as of any other subject. Finding a satisfactory composition involves organizing a variety of elements in a subject to create a unified whole with a main focus of interest, and if this means elongating or truncating a well-known building you should regard this simply as a part of the artistic process.

The first step is to explore whether your subject, and what you wish to say about it, is best suited to a horizontal, vertical or square format. Change your position, taking three-quarter views to see how this would affect the composition and, if the subject allows, try higher and lower viewpoints, which will dramatically alter the viewer's perception of the buildings.

Once you have decided upon the basic size, angle and shape of the buildings, you can begin to work out your tonal values and also your use of warm and cool colours to establish distance and mood. On a sunny day in an urban setting there will be plenty of shadows and you can use these to lead the eye to the point of interest, painting them from the imagination if need be – but take care to be consistent about the angle of light. Shadows are also very useful in indicating the time of day and the quality of light by their length and density. Because they are falling on stonework you may be tempted to paint them in a flat wash of dark grey or brown, but this risks deadening your painting; remember to look for the colours within them as you would with any other area of a subject.

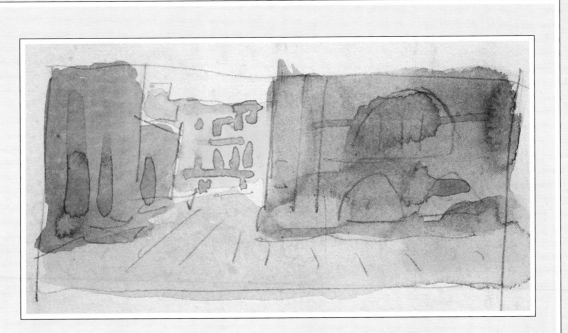

(above) Jenny made several attempts at a long, thin composition but thought that the Abbey was an awkward shape among the rectangles.

(left) Next she tried a long vertical composition but found that unsatisfactory, too. She did not like the proportion and felt that it did not add to what she was trying to do.

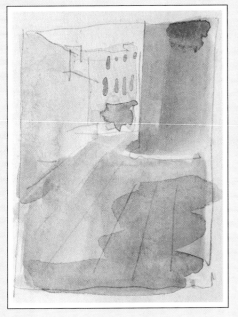

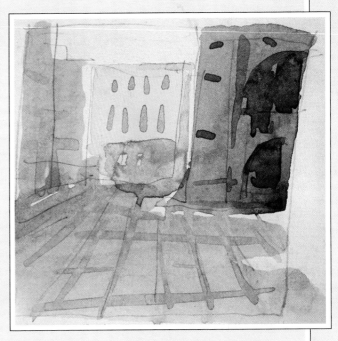

(right) Here the building is relatively square and is arranged within a square, a shape that Jenny likes. The colours are only suggested vaguely, but the arrangement of forms has been worked out to her satisfaction.

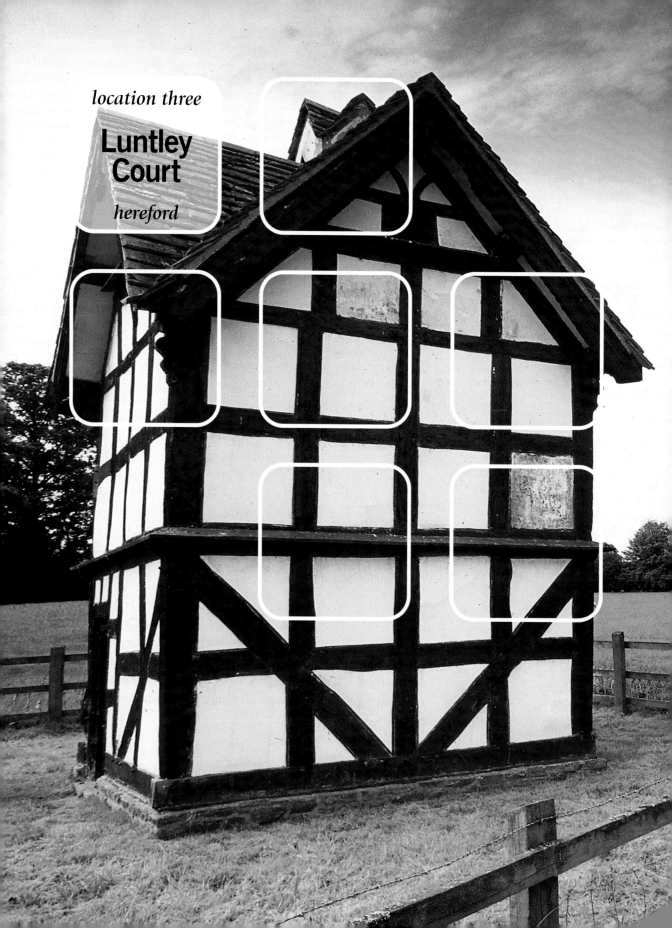

Herefordshire is one of England's most rural counties, with an affluent and distinguished past as a major centre of the wool trade that has blessed it with numerous handsome churches and the black and white timber-framed buildings for which it is famous. Ranging from quaint cottages leaning at angles that would rival the Tower of Pisa to magnificent manor houses, these dwellings can be seen on what is now called the Black and White Villages Trail. A circular route of some 64km (40 miles), the Trail takes in Leominster, Pembridge, Kington, Dilwyn and Weobley, perhaps the finest of all, with a history stretching back to the 7th century.

Just off the trail, close to Dilwyn, lies the hamlet of Luntley, a cluster of timber-framed buildings set in green fields enclosed by dense hedges and grazed by the descendants of the sheep that gave the county its medieval prosperity. In one of those fields is a dovecote, its black timbers and wattle and daub panels echoing the manor house to which it belongs – Luntley Court. The house was probably built in the early 17th century but was greatly enlarged in about 1674, the date that can be seen in the porch. It is likely that the dovecote, bearing the date 1673, was built before work on the house took place to provide a source of food for the labourers. In 1713 the house came into the possession of the Burlton family, successive generations of whom lived there until the latter half of the 20th century.

Although Luntley is now an isolated spot, in the Middle Ages the land was quite heavily populated with farmworkers and the fields still show signs of irrigation systems made to provide water for the flocks of sheep that were such a vital source of income. In 1240 Henry de Penebruge, Lord of the Manor at nearby Pembridge, was granted a charter allowing him to hold a weekly market, a Cowslip Fair in spring and a Woodcock Fair in autumn – a sign of a busy and thriving community. A gradual drift from the land would have begun with the birth of the Industrial Revolution in the 18th century, but even so the Methodist Chapel Primitive near Luntley was able to field 70 children in its congregation in the early 1900s. Now, however, the overwhelming atmosphere at Luntley is one of a deep tranquillity, which was only slightly disturbed by the arrival of the Watercolour Challenge wagons and three mildly apprehensive contestants.

There was good reason for apprehension at this location. The view consisted of a variety of greens in the fields and trees, always a tricky thing for watercolourists to handle, and of a black and white manor house and dovecote, which could prove even harder. Knowing that incautious use of black can deaden a painting and that this ultimate in tonal contrast might throw their composition out of balance, the contestants gamely met their challenge head on.

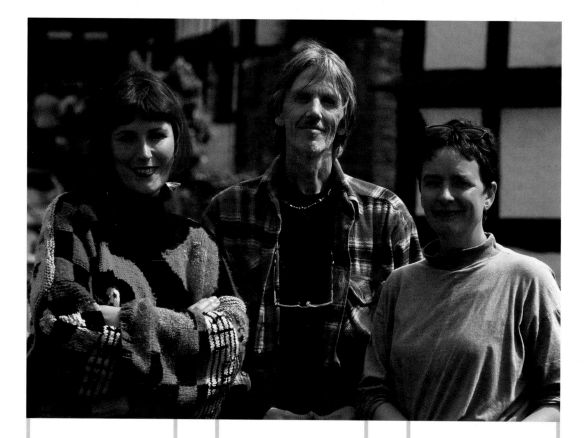

Madeleine Lancaster

Rex Foley

Eve Smith

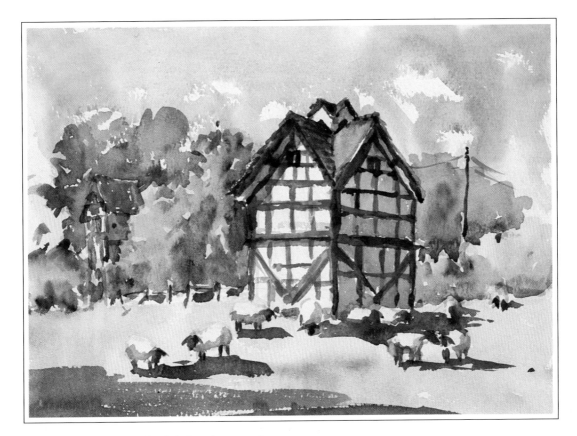

Concentrating on the interplay of light and shade in her picture, Madeleine gave emphasis to the foreground shadows to provide contrast with the lighter areas.

Madeleine Lancaster

The daughter of artist Sydney Vale, Madeleine studied art at Ludlow College and Bourneville University and has been painting for 20 years. She is a member of the Powys Girls Art Society and cites her influences as her father, John Blockley and Edward Seago. A former model, she is now a picture framer and gallery owner.

Colour, movement, sensation and atmosphere are important to Madeleine and she dislikes detailed, photographic work. Here she concentrated on light and shadow, after making some initial sketches to make sure she got the perspective right. She began her painting by building up the house and trees at the rear of the dovecote and the sheep in front of it with a No. 12 brush and a No. 6 for finer details, using blues for the more distant trees to give a feeling of recession. She left the foreground until last, adding shadows in a colour that contrasted strongly with the light green of her field.

Rex Foley

Rex was born and raised in the Forest of Dean, and the time he spent working there for the Forestry Commission gave him the urge to interpret what he saw through the medium of paint. Rex loves the transparency and unpredictability of watercolours and pushes their potential still further by using salt or sand, and by applying paint with a knife, his fingers or whatever comes to hand.

Rex began his painting by making a rough drawing. He then laid a wash of French ultramarine with a little alizarin crimson for his sky before moving on to the foreground and building. After putting in the lines of the black-and-white dovecote he toned down the shadowed right-hand side with subdued blue, then darkened the green foliage on the left-hand side of his picture with burnt umber to create balance. Gradually adding pinks and ochre to the building, he gave form to its ancient surface, using dry brush technique here and there. Paint spattered from an oil painter's brush added texture and interest in the foreground.

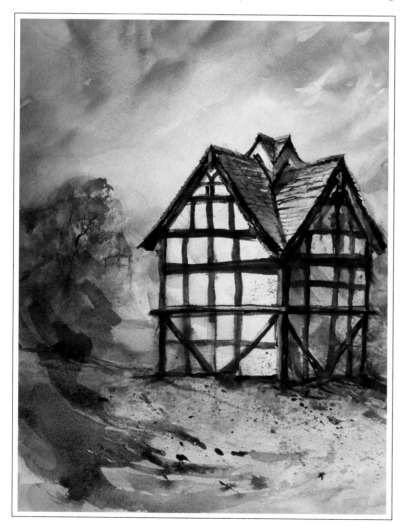

The dovecote is the only defined part of Rex's painting, with the trees to the left and house beyond merely suggested with loosely handled colour.

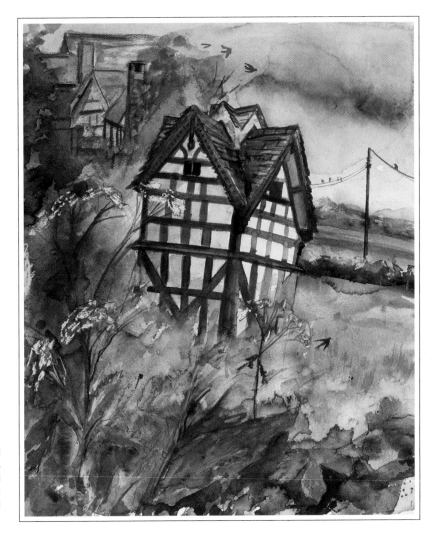

(right) Eve took a dramatic approach to what was essentially a tranquil scene, adding a colourful foreground and a turbulent sky.

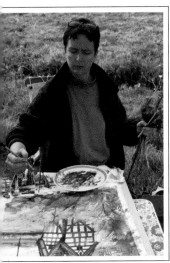

Eve Smith

Eve's path to *Watercolour Challenge* began with a birthday gift of a set of watercolours from her father, and it was also he who encouraged her to apply to be a contestant. In spite of the demands made on her time by three children and a job as a cleaner, Eve says she is addicted to painting and she is a member of both the Cardiganshire and Aberaeron art societies.

At Luntley Eve decided to make her painting about the atmosphere of the day, exaggerating the leaning walls of the dovecote and using plenty of colour. She did not want to paint the sheep, so solved the problem of a potentially featureless foreground by picking a large bunch of the cow parsley and other wild flowers that grow luxuriantly along the lanes and placing it in a jar in front of her. Her painting began with several very wet washes and she then built up her colours from there, using pastels to highlight the flowers in the foreground and the hedges.

'When I first arrived here I thought I would concentrate only on the wider view,' said Mike Chaplin, settling in for what was a promisingly sunny day on location. 'However, closer inspection and some sketchbook work has revealed all those things that excite an artist over and above the obvious subject matter. I like the little bits of geometry in the corner of the dovecote, the fence and the gate behind – if you isolate that area from its surroundings it looks like a Mondrian, purely a design of repetitive structure. There's a lovely dark diagonal on the dovecote and on the gate there's an almost exact diagonal. As an artist I find it more intriguing and moving than Luntley Court itself, lovely though that is. I'll note that mentally as something to tackle later in the day. For now, though, I'll do some sketches that would make a foundation for a more representational painting of the location.'

One of the fundamental choices an artist makes when it comes to composition is the format in which to place the picture. Mike began by trying out a horizontal format, which made the most of the spreading tree to the left of the dovecote.

'Perhaps a double square would give the subject a chance to breathe,' he said thoughtfully. 'I'll try a sketch to that proportion. A horizontal double square is a very typical Victorian landscape format. Because our eyes are placed

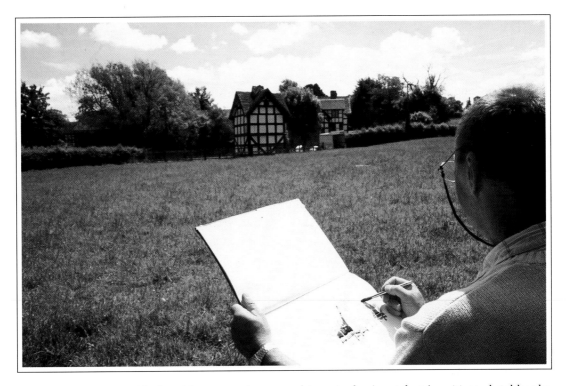

side by side we tend to see things in horizontal strips. Most sketchbooks, though, are far more square in format, and as we often tend to work in sketchbooks initially, the temptation is to record the view and just stop drawing the subject matter because we get to the edge of the page. I continually have to tear pages out and stick them on to the edge of what I'm working on so that I can get in what I can see, which is naturally a double square.'

His sketch done with a 6B pencil to allow easy recording of tone, Mike went on to explain, 'If you also include what you see peripherally in a landscape, you tend to get four squares in a row. This little sketch is slightly bigger than a double square; it is about two and a quarter squares, which for me gives the balance between the man-made geometric structure of the building and that much more organic sweep of the tree on the left. The format gives them a chance to breathe and to react together, so that we start on the left with an organic, dramatic sweeping statement, which then encounters the house and becomes far more geometric and square, with defined sharp angles. It then deteriorates again at the top right, so there is a pattern of rhythm there from organic to geometric and vice versa.

'In the patterns of the top of the trees on the left there is a repetitive vertical structure which is echoed in the vertical structure of the fence. Just to the left of the building the fence is seen light on dark, then right in front it is dark on light before reverting to light on dark again on the right-hand side, so there are linear counterpoints here as well as the organic trees against the man-made geometric fence.

'It's easy to forget that the rules of perspective also apply to shadows. They too have a vanishing point and go back to the source of light, so here the shadows on the left lie much more obliquely than those on the right, which are at a much more acute angle. Just those few little lines give that very small area on the left much

more space. In sketches like this I am still learning and trying different things, and that is why the act of creating art remains so exciting.'

In this apparently simple pencil sketch in horizontal format, Mike incorporated a counterpoint of organic and man-made, and of light tones against dark. Even the shadows stretching forward from the fence give information about the angle of light and the perspective of the scene.

Mike was called away to give a half-time judgment on the contestants' work, but when he had finished he returned to his exploration of the composition. This time he made a sketch in portrait format, using ink applied with pen and brush.

'Comparing this sketch with the horizontal one, you can see immediately that this has a totally different feel about it,' he said. 'The elements are all the same but it's far more claustrophobic and thus has more tension inherent in it. I've used washes of ink here, so as well as the linear juxtaposition between organic and geometric there is also another counterpoint of what is linear and what is an area of tone. I'm pushing it now towards painting without yet getting involved in colour, so I'm having a look at tonal structure as much as anything else. Once tones have been painted in, it wouldn't be much of a jump to exchange tone for colour and you could find yourself quite happily in the activity of painting, but with all the strength that you have discovered by doing a linear drawing and a tonal drawing at the same time. It bridges that rather difficult bit when people have got their ideas sorted out as a drawing but then worry about how they're going to do the real thing. They often forget all the useful things about the tonal and linear values of the subject that they've just learned about in the drawings and revert to doing a weedy, thin painting.

'About halfway through doing a painting I'll take it off the easel, put it in the landscape and walk away from it without looking at it until I am about 15 metres away. I then turn round and look at it and if it isn't very visible I'm quite pleased, because that means it has disappeared into the landscape in terms of both colour and tone, and therefore I must be making quite rational judgments about these elements. Generally speaking, though, what I tend to see is a pale little bit of paper with nothing positive on it at all!

'These two sketches are exploring two things: what is happening in the image and the relationships that are available

This ink study of the building and trees in a portrait format has a dramatic quality engendered by the vigorous verticals and the claustrophobic feel. Compared to the horizontal sketch, with its spreading tree and landscape stretching beyond, this study of the dovecote looks far from peaceful.

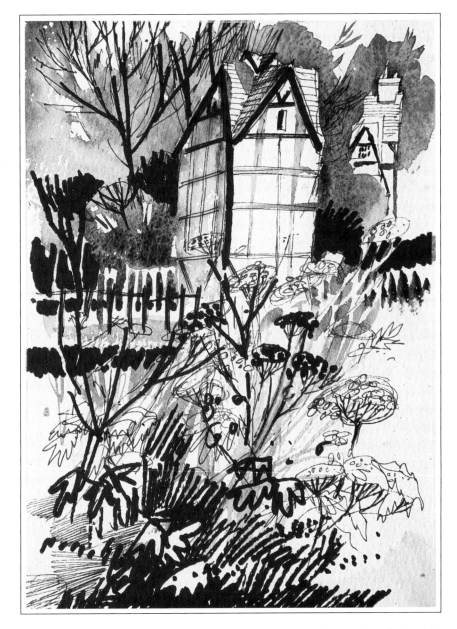

to the artist as subject matter. In a sketch you can work out the relationship between organic forms and those that are much more geometric and structured; you can have a look at what is line and what is tone, what is textured and what is flat, what colour you might want to introduce and, more importantly, the format within which you are going to place these things. You can choose the format first and compose within it, or choose the subject matter and let the format establish itself once you have made the decision. You can slightly manipulate the subject matter to make it fit in, exaggerating or compressing certain elements where you wish.

'These sketches are so quick to do, but they give you so much vital information. I think that most of the contestants I meet would benefit from doing a lot more of them, but I can imagine that with the time limit they face they often feel pressure to get on with the painting itself.'

Mike was now ready to make his exploration of the geometrics of the dovecote and gate – and leaving it until later turned out to have been a good decision. 'When it was backlit this morning the diagonal of the gate was dark on light, but

(below) With a few brief washes of paint and some strips of paper, Mike assembled a little study of the geometrics he saw in the lines of the gate, fence and dovecote (left). Though it was only a very small area within the scene, it contained just as much to interest an artist as the larger view.

now the sun has moved right round and it has become light on dark. It's a very elegant counterpoint against the dark-on-light diagonal of the dovecote.

'This whole area is interesting in that the buildings are black and white, which are paints that most watercolourists won't acknowledge as being colour. So what do we do when we encounter man-made colours in a landscape setting? Do we ignore the fact that they're black and white, or do we modify the black into a very dark colour? The white will be more obviously modified by what the light is doing to it – you will see cool blues in the shadows and you might even get quite a lot of reflective light coming from grass round the bottom. A black tends not to be modified by surroundings so much unless it is a gloss black, in which case it will reflect a certain amount of colour and light. In the case of matt black, like the black here on the dovecote, there is a danger of it intruding into the painting – it becomes so flat that it leaps forward off the page and pushes everything else backwards. The trick is to use it very sparingly or exchange it with something that has the tonal value of the black but has a colour; you could mix it with a little bit of red to get a dark brown, which would tend to come forward, or with a little blue so it becomes a very dark blue and recedes.'

The contestants were now nearing their four-hour deadline and Mike knew that he would soon have to go and judge them. 'I'm short of time and this is just a little compositional idea, so rather than painting it, I'm just going to cut it out of bits of paper and stick it down,' he said, rummaging hastily in his kit. 'Apart from speed, the advantage of doing it this way is that you can lay the shapes ungummed on the paper and move them until you're happy with them before you stick them down. What you are doing is taking the basic essentials of a composition and playing around with them to see whether there's anything there that is worthy of a more permanent image in a watercolour. If the idea turns out to be a non-starter you have wasted very little time. Any paper glue will do, but you don't even need that – watercolourists often have a roll of brown gumstrip with them, and you can simply wet the back and borrow some glue from there. I've also borrowed glue from gumstrip to make paint more viscous and give myself more working time on the paper.

'When you look at this little collage your senses tell you that the brown fence is in front because it's the biggest area and it's overlaying the black behind, but your eyes tell you the black is in front of the brown because of its reflective nature. There might be an argument for thinking of the subject matter as being more suitable for a wood engraving, a linocut or a black and white pen and ink drawing. While we are obviously dealing with watercolours here, it's important for an artist to keep an open mind as to which medium might best suit the subject.'

PROJECT

Greens can be tricky for a watercolourist, and the problem with the classic mix of lemon yellow and manganese blue is that it lacks sufficient depth of tone. Using a mix of blue black and cadmium yellow or burnt umber and Prussian blue opens up a range of greens that are subtle but also have tonal depth.

Many artists paint the greens in a landscape in too light a tone. As an experiment, lay a leaf on a sheet of white paper and apply paint of the same tone; you will probably be surprised at how deep it is.

DECONSTRUCTING A SCENE

Before starting a watercolour painting, mentally deconstruct your subject into line, tone and colour. In practice, you deal with all three at once – you put down a colour that has tone, and when you lay down another colour next to it there is an implied line between them. In the beginning, however, it is useful to investigate all three as separate operations, either in three studies or by building them up on one piece of paper as Mike did here.

Beginning with line, he looked for the linear structure of the buildings and of the trees, using pen and ink and also spattering the ink lightly by flicking it off the end of a brush. A linear sketch can be made with a variety of media, including charcoal, pencil, pastel or the point of a brush.

For a tonal sketch, there is also a choice of media. In his sketch of Luntley Court Mike continued to use ink, now applied with a brush and in various dilutions, as he investigated the range of tones within the scene. Charcoal and pencil are easy to use for a tonal sketch, and are perhaps more practical than ink if you want to pare your kit to a minimum for taking on location. Another possibility favoured by many watercolour artists is to use one pigment in various dilutions to make a monochrome sketch, which can make an attractive painting in itself.

The colour treatment can be done with fast, loose washes of paint, which will make you feel confident about how you will tackle the finished painting. At this stage, you can establish the colour balance that you will eventually use. Watercolour pencils or pastels are equally useful for making what are essentially just colour notes.

Once you have completed the above process, you have laid down the groundwork for your finished painting. While you may decide to emphasize one element more than another, you have worked out the balance of tone, colour and line, and, provided you refer to your sketch or sketches as you work, your painting should be compositionally well balanced.

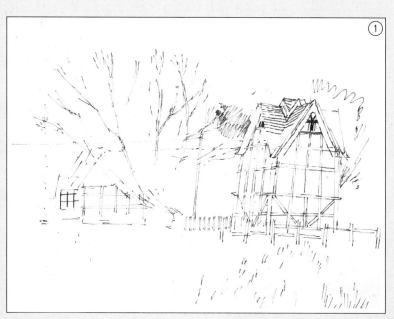

1 Here the linear details of the scene have been drawn with pen and ink, the most defined part of the sketch being the dovecote with its pattern of timbers.

2 The tones are now established in the same sketch, using dilutions of ink applied with a brush. The dark tones of the trees are an effective contrast against the lighter buildings.

3 A fast, loose wash of green is enough to establish the colour balance of the future painting. The three elements of line, tone and colour are all now present in one sketch, which can be used for reference immediately or later in the studio.

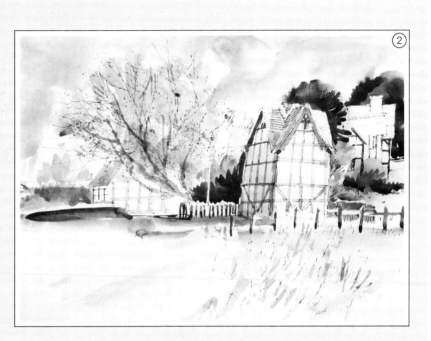

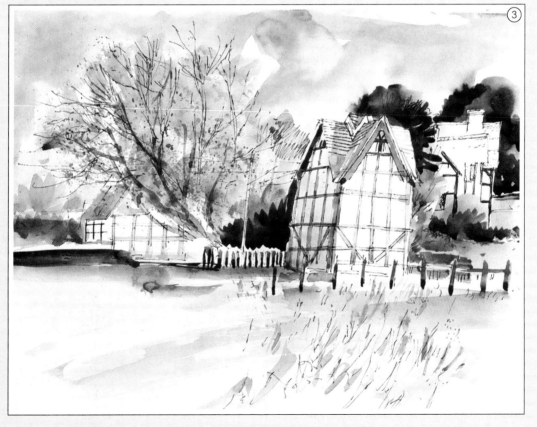

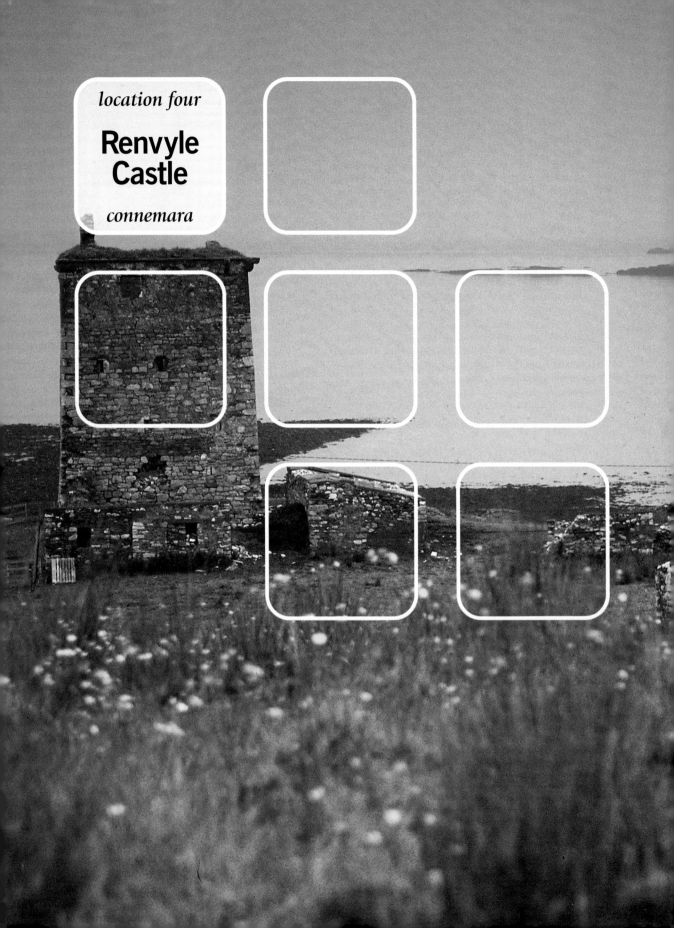

location four

Renvyle Castle

connemara

Connemara is a place of legendary beauty, and the quality of its light has attracted artists for centuries. Indeed, Augustus John described the Renvyle Peninsula as 'the most beautiful landscape in the world'. With such a recommendation, it was a natural choice for Watercolour Challenge.

As the glaciers of the last Ice Age melted away 10,000 years ago, they left in this part of western Ireland a land where imposing mountain ranges rise dramatically from the sea, in striking contrast to low-level blanket bog where the peat is up to 5 metres (16 feet) deep. The high level of rainfall, coupled with the warming influence of the Gulf Stream, provides a climate in which the winding roads, patched and repatched where they have sunk into the bog, are lined with fuchsia hedges, and the meadows are glorious with wild flowers.

Idyllic though Connemara is, it also offers poignant reminders of the terrible effects of the potato famine. This was formerly one of the most densely populated parts of Ireland, its prosperity derived from fishing and the potato crop. The land has been farmed here since Neolithic times; the remains of Bronze Age settlements and burial monuments show that white quartz stone, granite, soapstone, copper and gold were all in use. In some places, shellfish middens left by shore-dwelling communities contain deposits of dog whelk shells, which were used to make purple dye valued by the Romans. After the arrival of Christianity in the fifth century AD, Connemara became a region of important monasteries. Until the 18th and early 19th centuries the population increased steadily, but then in 1845–52 the potato blight, coupled with some of the worst winters of the century, caused a collapse in the population that left farms and even whole villages deserted.

The intention had been that the Watercolour Challenge contestants should paint the stunning view up the coast towards the mountains, but poor visibility meant that the focus was switched to Renvyle Castle. The castle dates from the 16th century, when a family known as the Ferocious O'Flahertys built a series of castles along the coast. At one time, it was inhabited by Granuaile, or Grace O'Malley, a warrior queen whose army of 50 men preyed upon English ships making their way up the west coast of Ireland. In due course she found it expedient to make a treaty with Elizabeth I of England in order to be exonerated for her crimes, and attended a meeting with her that was conducted in Latin. A highly educated, courageous and strong-minded woman, she was married twice to husbands of her own choosing, the second being Donal O'Flaherty of the powerful Connemara clan. After his death the O'Flahertys tried to dispossess her of Renvyle Castle, whereupon – adopting a policy that if she could not live there, no one else would – she had the castle bombarded by cannon fire that ripped a hole in its seaward side.

For all its exciting past, the scene at Renvyle today could hardly be more tranquil. The Watercolour Challenge vehicles lumbered slowly along the narrow lanes, bringing in crew, contestants and cameras to take up a place in a hilly field above the castle, with the view over the water that Granuaile was so determined to keep for her own four centuries earlier.

Eugene Rooney

Ronnie Garvey

Mary Coolen

In Eugene's painting the composition was based on a deliberate placing of the castle to the left, with a broad expanse of calm water to the right.

Eugene Rooney

Eugene has been painting since 1985 and did a diploma in Fine Art in 1987, followed by a teaching diploma in Art & Design two years later. He then taught art to children for some years before recently taking a sabbatical to study for a BA in Fine Art, during which time he changed from using a photorealist style to employing a looser approach.

Eugene is influenced by the American artist Andrew Wyeth, particularly in his liking for a slightly unbalanced composition. He used this style at Renvyle, placing his castle to the left of the picture and leaving a stretch of water to the right, which he felt gave balance by virtue of its broad expanse. After laying washes of blue-grey colour over the water and a green wash over the field around the castle, he put in the castle itself with the point of a small brush, taking care to retain some of the white of the paper. He then added texture by spattering paint carefully from a toothbrush, a technique he used more freely as he put in the foreground in the final stages of his painting.

A scattering of small houses crouch around the ancient stone castle at Renvyle.

Ronnie Garvey

Although he likes landscapes as a subject, this was the first time that Ronnie had ever painted on location. In fact, when he entered *Watercolour Challenge* he had not much more than a year's experience of painting under his belt, for with a laundry to run and seven children to bring up there had been little time to spare for art.

Ronnie had never been to Renvyle before and, with the mist hanging over the sea, he was unable to tell whether there were mountains ahead of him or not. Taking a gamble, he painted some in and was rewarded by the sight of them appearing in the afternoon as the sun burnt off the last of the haze. He never sketches, preferring to go straight in with the paint, and he began here with a wet wash. However, it dried so quickly in the breeze and sun that he revised his policy and used thick pigment and a dry brush to give himself more time to manipulate the paint, using cadmium yellow, Chinese white, burnt umber, cobalt blue, and a touch of red to represent sunset behind the peaks.

Taking a guess that there might be mountains across the water, Ronnie put in gentle hills that echo the shape of the islands.

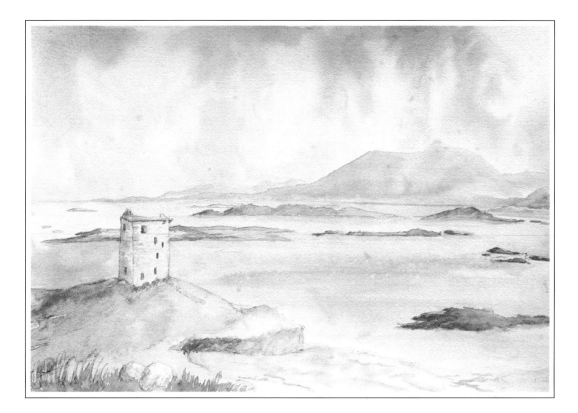

The delicate tones and colours in Mary's painting give the feeling of the hazy light of the location.

Mary Coolen

Mary has a physiotherapy practice in Dublin, but as she has family in Connemara and likes to paint the sea, the location was a familiar and well-loved one. She has been painting since childhood, though she says, 'Life has often got in the way.' Her ambition now is to be able to paint all the time. Turner and Cotman are the watercolourists whose paintings she most admires, and she describes her own work as colourful and structured.

Mary spent well over a quarter of her allotted time drawing, for she believes strongly that a successful structure must be the starting point of a good watercolour. She began painting with washes of yellow ochre, French ultramarine, Payne's grey and alizarin crimson in the sky, wetting the paper first and tilting the board to allow gravity to bring the paint down. The distant mountain was put in with a mixture of alizarin crimson and French ultramarine, the same colours appearing again in the water. Using a delicate tonal balance, she achieved a good sense of recession in a painting that expressed the feeling of a Connemara day.

THE EXPERT APPROACH

When Susan Webb arrived in the field overlooking the castle the day was still grey and misty, and to someone less familiar with the area it might have seemed that there was no land mass at all across the glassy calm water. However, Susan paints the area frequently and her instinct tells her where she will find a good view. Leaving the field with some reluctance – Susan is a horse-woman through and through, and a frisky Connemara colt was teasing the television crew with a display of kicking, bucking and galloping within feet of the equipment – she made her way down to the beach to paint a different aspect of the castle, walking a little way past it so she could get some perspective on it.

'I think it might be nice to include this winding road that goes up and down the hill and around the headland, with the lovely semicircular sweep of the beach in front and then the headland with a range of mountains behind. To the left of the sand are pools of water, then in the foreground there are these lovely big boulders, which are a really nice feature. For the *Watercolour Challenge* tip a couple of days ago I talked about three different styles of painting, and now I think I'll put my money where my mouth is and paint a scene in three different ways,' she said, rummaging in her bag for a particular sable brush she had just bought at enormous cost. 'When I'm doing a big watercolour for myself I will spend an entire day just drawing to make sure I get precisely the refinement of shape I want, and if I were a contestant I would spend at least a quarter of the time drawing. Today, I've only time to do some sketches, but I can still illustrate the points I want to make.'

Susan's first sketch was in traditional style. 'I'll be building this one layer upon layer and getting the effect of three dimensions by the use of tone, so I'll start with the palest tones in the sky, wash in the mountains and make those in the far distance disappear into the mist to get an exaggerated sense of distance. The nearer mountain will be a bit stronger maybe, with a little purple in it and possibly a tiny bit of green,' she said, setting to work.

In her tonal painting, Susan established a three-dimensional landscape where contrasts of dark and light were the dominant theme.

Susan had only just finished her first painting when the call came over the radio to say that she would be needed for a discussion of the day's challenge within ten minutes. Standing back from her easel to view her painting from a greater distance, she explained, 'The spit of land with the castle on it is a cadmium yellow-green and the next area of green behind that

goes into the distance, so it has a bit more blue in it. The spit of land behind that is ochre-grey-blue, to give the different levels a truly three-dimensional effect. A little of the colour in the mountain appears in the farthest stretch of low-lying land to make it sit into the distance. Then the grassy, sandy path coming towards us is an ochre-green to give warmth.

'The tide is going out and as I think the pattern of the seaweed and the rocks is lovely, I've made the most of that. In the distance, the water almost melts back into the mountains and the sky, and as it comes forward I've exaggerated the colours. I've painted a darker band about two-thirds of the way down the water so that it looks very deep there. The sandy slope of the beach running down into the tidewrack has been put in rather more golden than it is, and the tidewrack itself has also been exaggerated to a richer burnt sienna than the reality.

'Because I've painted this picture by building layer upon layer of paint to give the depth of tone, I've been aware all the time of tone. Consequently, every-where I've had the opportunity to exaggerate depth by contrast of light and dark, I've done it. The little bit of blue running through the stones in the foreground is a nice counterfoil to liven them up. The stones there are all different colours – blue ones, yellow ones, brown ones are all mixed together – but I have exaggerated their tones rather than their colours.'

While Susan was away from her chosen location the sun came through more and more strongly, and by the time the crew had finishing filming, the true colours of the landscape were beginning to appear. This was a piece of luck, as she was now moving on from a tone sketch to one that concentrated on colour instead.

(below) For details such as these, Susan advises that an artist should always work from a drawing in a sketchbook. If you are using a photograph for reference, make a sketch first and then paint from your sketch rather than working directly from the photograph.

(bottom) This detail of the painting shows the handling of the foreground elements, where the tones are stronger and darker than in the distant landscape. Different coloured washes laid one on top of another describe the form of the rocks.

'This style is associated with more contemporary work, although Turner used this method beautifully in his late paintings,' she said. 'Instead of painstakingly building up three-dimensional form, he suggested it with colour and a bit of texture and tone and left the viewer to interpret what they were saying, thus giving the viewer a more active role. For this one I'm making a much more dramatic sky with plenty of runs and stronger colours – purple, lemon and cadmium. This is a much looser interpretation, so the washes are applied with much greater freedom in one bold stroke and there isn't the careful build-up of wash on wash. I'm using a higher-key palette to give much more colour and much less tone, so I'm getting my depth by contrasting warm and cold hues rather than light and dark tones. Of course in the first technique you use a bit of colour as well as tone, and in the second technique there is tone as well as

colour, but colour is more predominant and the effect of this is that it becomes a much more moody and emotional picture. It's one where I'm expressing how I feel about the place rather than describing what it looks like.

'The mountains are quite strong, with the depth indicated by colour rather than by pale tones. The foreground is very loose with strong bits of colour dropped in, the orange on the beach contrasting with the cold mountain in the background. The stones in the foreground and middle distance are much looser than the more carefully described and modelled ones in the first picture. They are suggested with blobs and streaks, and there is some texture with spots that can be interpreted as flowers. There's a strong, dramatic shaft of sunlight hitting the castle and warming its colour. I've been quite free about the use of white gouache in this painting.'

Putting her second painting carefully aside to finish drying, Susan put a third piece of paper on her board. 'We're running out of time and this painting will have to be quite sketchy and rough, but it's the method that's important,' she said. 'It will rely much more on a linear approach so I'll spend more time drawing, though not as long as I would if I had unlimited time.'

The day was indeed wearing on. The crew and contestants were basking in the afternoon sun after tucking into a late lunch of Irish stew cooked in the guesthouse that lay at the foot of the steep hill, while the Connemara pony had gone a step too far in trying to bite one of the cameras and had been penned up in a tiny field in the shadow of the castle. The day was so beautiful that no one wanted it to end, but the four-hour limit was approaching fast and Susan did her final painting in record time.

'This picture is mostly line, and the line is terribly obvious because it's done in Indian ink, and is completely uncompromising,' she said. 'The rocks in the

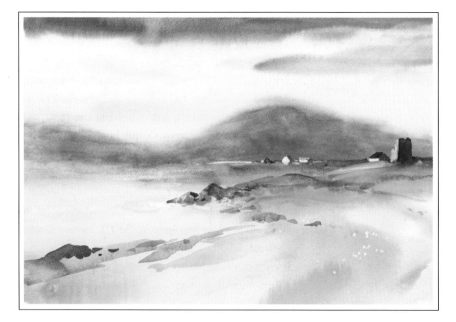

In her second painting, Susan expressed depth by her use of warm colours in the foreground and cold ones in the distance. The handling of detail such as the stones on the beach is much looser and much is left open to the viewer's interpretation.

Here the elements of the picture are described in line, with simple washes of colour playing a descriptive but subsidiary role.

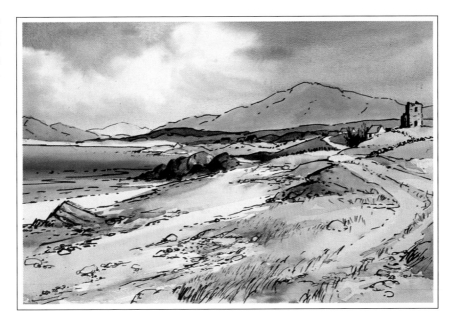

foreground are carefully drawn, the few to suggest the many but all line-based; the castle and the road are also carefully drawn in, with the stones of the wall leading our eye up to the castle. The washes are there just to fill in the spaces to support the line, so really this is a coloured drawing. You can make your line as subtle or as obvious as you like with this method – you could pick out a lot more detail in the foreground and background and be subtler with it, but you can be quite bold if you want to. I have used some colour through the washes, some warm and some cold to give the feeling of where the sun is hitting or the shadow is falling, but there isn't a lot of modelling in any of the paint.

'Sir Rowland Hilder uses this method – the line is very important in his work, but of course his paintings are more subtle than this. All colour here is simple and subsidiary and the picture relies on the line. The bright colour in the water doesn't give you a three-dimensional sea; that comes from the squiggles and swirls of the waves, and the mountain would be completely formless but for the little bit of detail picked up with the line, showing the crevices in it. I haven't even bothered to put any colour into the bushes around the house; they are just black Indian ink, but it works because the strength of the line is carried throughout. When you work with Indian ink you need to be consistent all through the picture; if you use it in just one part it will probably look too dark and heavy.'

Packing away her kit, Susan said, 'I've exaggerated the technique in these three paintings to show the contrast between them, but I'll be back here soon to paint just for myself. There is incredible material for an artist in Connemara and I have such a strong feeling for the area. Right now, though, I have to go and pick the winner from today's contestants.'

technique

USING MIXED MEDIA

The term 'mixed media' includes virtually any medium that can be used with water-based paint, but excludes oil-based media because these will eventually eat into the watercolour paper. Coloured crayons, wax crayons, plain wax, pastels, gouache, acrylic, ink and even collage are all suitable, although Susan Webb prefers to use just enough mixed media to give a textural effect because she likes the more intense colour that watercolour gives in comparison to gouache or acrylic.

As the nature of mixed media is somewhat crude, it only succeeds if you are prepared to be quite bold with it. Be stronger in your drawing, bolder in your shapes, simpler in your composition and give yourself the space to play with the texture, which is the sole reason for embarking on a mixed media painting. If you make a mistake with your watercolours other media can sometimes be handy to conceal it, but the concept of a mixed media painting is altogether different.

Texture is variation of surface, and the bolder the variation of surface and the more colour there is in a subject the more suitable it is for mixed media. Because you will be using such strong colours, you will need a lot of water to clean your brushes and probably a large number of tissues or kitchen towels, so make sure you are well equipped before you go out. Lay out all your materials before you begin painting so that you do not have to stop in the middle of some big and bold treatment, and allow generous quantities of paint – you will be surprised how much you will use.

Inks can be applied with a pen or brush; an architect's pen is useful as it gives a variety of line depending upon the angle at which you hold it. Big brushes can be supplemented by a palette knife for bold sweeps of paint, and although the effects with a knife are less predictable you can enjoy working spontaneously with the texture that results. Work on paper of a weight no less than 425gsm (200lb), because a lighter paper will become overloaded with the weight of the paint. A Rough 600gsm (300lb) paper will absorb a lot of water, but is stronger and has a rougher texture that can be emphasized by the use of dry brush technique to add to the variable surface given by the use of mixed media.

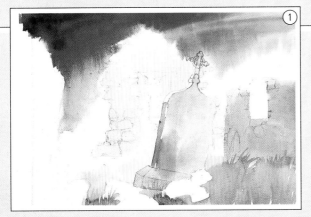

1 Susan began a mixed-media painting by drawing her composition. She took less care over accuracy than she would do in a pure watercolour painting, because with mixed media she would have more scope for altering small details later on. Her next step was to lay in bold washes of watercolour, wetting the paper first and tilting the board so that the colour ran. Working with a large brush in one hand and a tissue in the other, she covered the whole paper to banish all its whiteness so that she could see her picture in blocks of tone and colour.

(above) Use of both acrylic paint and watercolour on the wall gives a sense of the texture of the ancient stone.

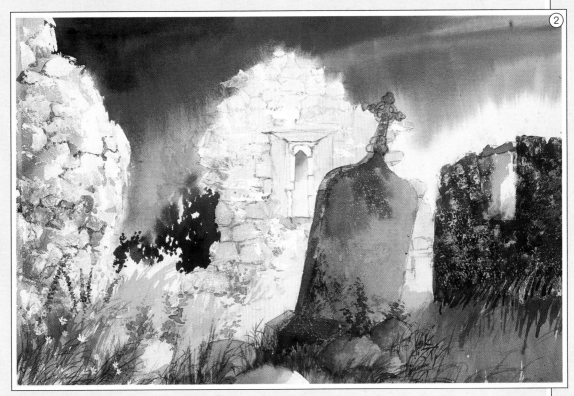

2 With bold use of colour and texture, Susan created a dramatic picture of a tumbledown church where the vegetation was eclipsing man-made structures. Using a palette knife, she applied white acrylic paint to the wall with a sweeping sideways movement, using it in some areas only so that she achieved a feeling of texture without it becoming overpowering. Once it was dry she laid further washes of watercolour on top and then, using the point of a No. 5 sable brush and denser paint, picked out the lines of the stonework. She rubbed candle wax on to the tombstone to provide a resist and then applied some more washes over it, with the result that her earlier layer of paint showed through the waxed areas, giving texture and form.

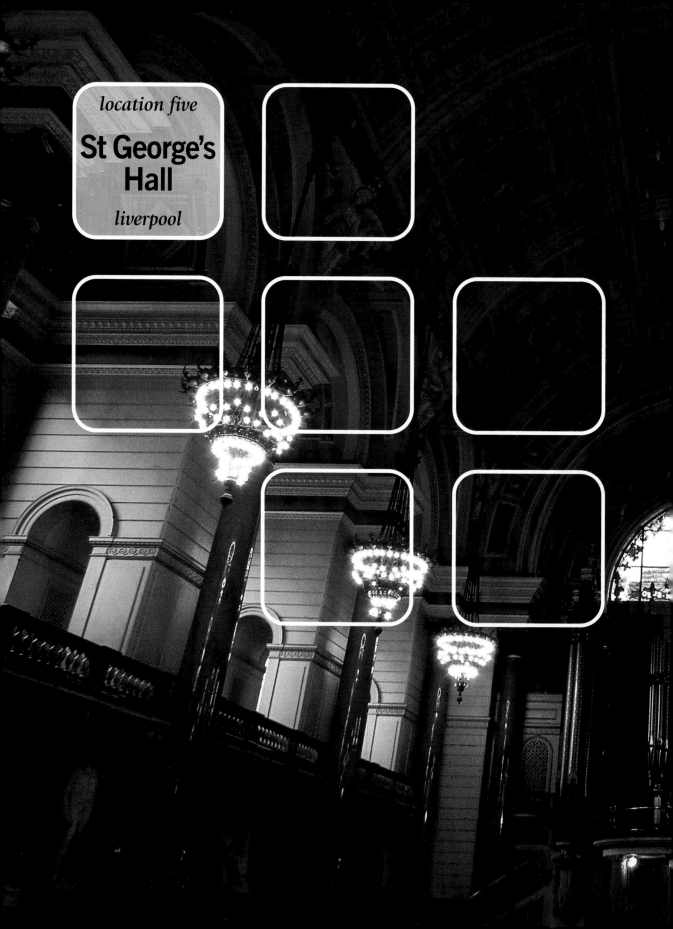

location five

St George's Hall

liverpool

The magnificent Neo-Classical building that stands opposite Liverpool's Lime Street Station is a symbol of the prosperity and confidence of the city in the 19th century and of the Victorian ideals of self-improvement and charitable endeavour towards the poor. Although St George's Hall was not opened until 1854, the idea of a concert hall in which to hold fundraising musical festivals for local charities was conceived nearly 20 years earlier. Money for its construction was raised by subscriptions and by the sale of shares, and the foundation stone was laid on 28 June 1838 to mark the coronation of the young Queen Victoria. The following year a competition was announced to find a suitable design that would cost no more than £30,000 to build and was won by Harvey Lonsdale Elmes.

Elmes's proposed plan was in fact going to cost £35,000, so to raise more money it was decided to combine St George's Hall with the new Assize Courts, which were also designed by Elmes. The final cost was £300,000, a tenfold escalation in price from the committee's original plan. But Elmes never saw his grand commission completed; he had a delicate constitution, and the repeated seven-and-a-half hour train journeys from London to Liverpool as he tried to supervise his various projects proved too much for him. In September 1847 he set off for Jamaica to spend the winter in milder weather and just two months later succumbed to consumption. The building was finished by Charles Cockerell, architect of the Ashmolean Museum in Oxford.

The Great Hall in which the Watercolour Challenge contestants found themselves is Roman in inspiration. Measuring 51.5 metres (169 feet) long and 22.5 metres (74 feet) wide, its length is divided into five bays by sets of six granite columns and it has a vaulted ceiling beneath which are winged angels representing Prudence, Fortitude, Science, Art, Justice and Temperance. Under Cockerell's supervision a Minton tiled floor was laid, containing an estimated 30,000 tiles, but this was covered in the 1860s with a wooden floor more suitable for dancing. The only section now on view is beneath the organ balcony. Above it towers the organ itself, built by Henry Willis between 1851 and 1855, and the finest in the country until a larger one was created in the Royal Albert Hall in London in 1871. It consists of 7,737 pipes and was originally powered by a steam engine in the basement.

The Hall's first event in 1854 was a three-day music festival, which was followed over the years by a range of activities including bazaars, rallies, prize-givings and banquets, including one held on 10 April 1869 in honour of Charles Dickens. Many were high-minded events such as, in February 1900, a 'Grand Bazaar in aid of a great work for feeding the hungry, dieting the sick, cheering the cheerless'. Now, in June 2000, three amateur artists were facing the challenge of painting the monumental architecture of the hall and the diffuse light that pervades it. The angels of Justice, Science and Temperance were not needed, but those of Prudence, Fortitude and Art most certainly were.

Bernie Smith

Jane Stafford

Earl Gaunt

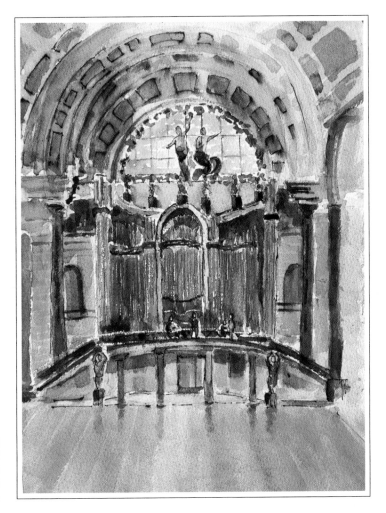

The fresh, colourful handling of the stained glass window in Bernie's painting makes it the main focus of attention.

Bernie Smith

A Liverpudlian born and bred, Bernie has travelled worldwide and his past employment has included spells as a merchant seaman, a pub landlord and a plumber. After returning to his home town he signed up at Liverpool Community College, where he sat his A Level Art exam shortly before competing on *Watercolour Challenge*. Much of his knowledge of painting has come from copying the work of earlier artists, most notably the Impressionists.

Bernie decided to start his painting from the centre and build out. He tries to achieve an effect as soon as possible so that he can see where his picture is going, and he soon fixed on the stained glass window as his focal point. He wanted to depict the luminosity given by the window to bring the picture to life, so although he put in a lot of colour he also left plenty of white paper. The combination of the fresh treatment here and the use of different colours from those in the rest of the painting successfully draws the viewer's attention to the main point of interest.

Jane Stafford

Jane's career as a nurse came to an abrupt end six years ago when she suffered a heart attack. Now fully recovered, she has opted not to return to her stressful job but to do voluntary work with disabled artists instead. Jane has been painting on and off for 20 years and belongs to a local art group. Her style is to begin with a quite detailed pencil drawing but to then lay down very loose washes of colour.

Initially overawed by the monumental interior of the hall and feeling there was not enough time to include a whole section of it, Jane decided that she would paint the organ using stained-glass colours, thereby combining two elements of the scene into one. To get the background colour on quickly she applied it with a sponge, which she describes as 'free and funky to use'. As she loves playing with colour, she then concentrated on building up jewel-like colours on the organ, with some detail put in at the end with a fine brush and crayon.

In Jane's impressionistic painting, pigments suggesting the colour and translucency of stained glass were used in the organ.

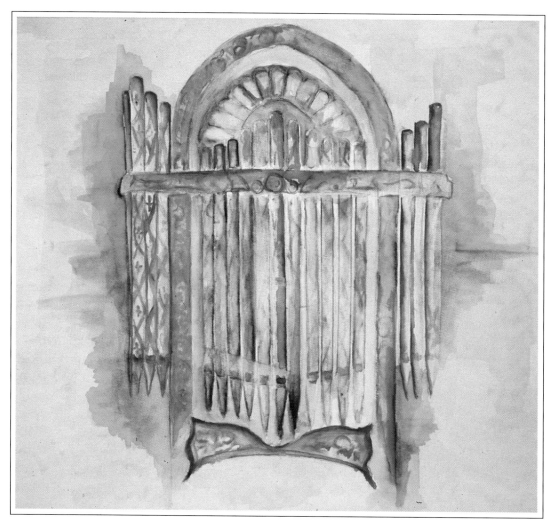

Earl Gaunt

Earl has been in the scrap metal industry for most of his working life, but in the three years he has been painting in watercolour he has developed such enthusiasm for it that his wish is to become a professional artist. He attends classes at Tameside College in Ashton-under-Lyme for two hours a week and spends all his spare time painting. Edgar Whitney has been his main influence.

Deciding to take a slightly abstract approach to the subject, Earl made the organ the essence of his picture. After his initial unifying wash of raw sienna all over the painting had dried, he darkened the area behind and beside the organ to make it the focal point and to create depth in his picture. He then wiped off paint with a diagonal outwards movement, giving the impression of waves of sound emanating from the organ and also leading the viewer's eye towards it. He put little detail in his painting, but added in five notes from the score of 'Eleanor Rigby' to represent the Beatles and Brian Epstein and their place in the history of Liverpool.

THE EXPERT APPROACH

There was a distinct air of hush when *Watercolour Challenge* took place in the Great Hall, partly because the slightest sound was magnified by the acoustics and made life difficult for the sound recordists, but also because the grandeur of the Hall demanded it. Although it has hosted plenty of concerts, balls and grand dinners, its presence more than dwarfed a small TV crew and four artists.

While the contestants began work on their initial sketches, Jenny Wheatley walked quietly around the hall, considering it from various angles. 'I think this is going to be difficult for the contestants, because although it looks as if there is a lot to paint it's rather like a big stage set – there's a lot around the wings but the centre of it is left very empty,' she said. 'An artist who likes the idea of figures on a stage might put people in the scene, using the grand building like a frame. As it is, all the detail is around the edge. It could make an exciting painting if you have the courage and the single-minded intention to allow the blank space to occupy the centre.

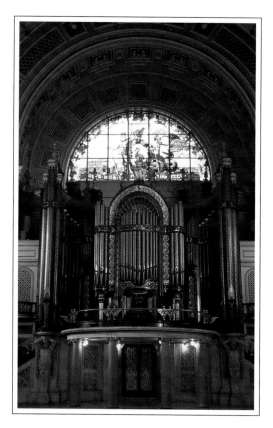

(above) From where the contestants were seated, the view straight down the hall culminated in the magnificent organ and the stained glass window, complete with a liver bird above it.

(left) Seated beneath the organ balcony, Jenny concentrated on making some sketches of the details in the hall's architecture.

(above) Jenny took a high eyeline in this sketch, with directional marks on the large expanse of floor leading the eye to the organ.

(top right) Here the floor has been eliminated and the viewer appears to be looking down on the door beneath the balcony, its presence signified by a tiny figure.

(right) While the pillars are lightly indicated, the main focus of this sketch is the chandelier.

'One of the biggest dangers here is the temptation to home in on the organ, which is flat on, with no passages through. Instead, the contestants need to think about their personal response to this monumental hall, and what they want to say about it. Composition is vital in this. Ideally, they should do several drawings at different spots and then arrive at a final composition that uses elements of all the little sketches they have made.

'One possibility would be to concentrate on the ornate ceiling, with the organ dwarfed at the end of the hall; alternatively, you could put in a lot of floor and make a vertical composition to show the height of the building. You could

also just look down the sides, with all those pillars and statues. It's important to try different eyelines and to explore all the possibilities.'

So saying, Jenny took herself off to investigate various viewpoints for herself. By the time she returned to check on the contestants' progress she had covered several pages of her sketchbook.

'I use my sketchbook as a thought process,' she said. 'I was very impressed by the huge space and the detail happening around it, so I thought I'd set my eyeline very high up in my first sketch. This way the organ balcony and the area

(top) This frontal sketch of the sculptures expresses the weight of the organ balcony bearing down upon them.

(above) Taking a side view of the area beneath the balcony, Jenny brought one of the sculptures that so attracted her into the foreground.

beneath it become a very small part of the composition. If I were to paint this there would be an ecclesiastical feel to it, with everything leading up to the organ and the stained glass above it.

'Next I got rid of the floor, included some of the ceiling, and made more of the liver bird in the window. The effect here is of looking down on the door beneath the organ balcony. Next I decided to leave out the organ altogether and look instead down the side of the building, sketching the chandelier and concentrating more on the light in the hall rather than the architecture; the lovely glowing light is a big part of the atmosphere here.

'Finally, I arrived at the subject that first struck me when I arrived – the lovely figures to either side of the organ balcony. I sketched them first across both pages of the sketchbook because I liked the feeling of them being either side of a mantelpiece, putting in four pillars but nothing of the balcony itself, as I was interested in the sculptures here. All the marks point towards them, and there is a lot of weight bearing down upon them. I wanted the feeling of figures that would move if you turned your back for a moment.

'Taking a different view of the sculptures, I indicated more of the beautiful floor pattern. There's a crumbling feeling about the sculpture here, as if he might be about to give up and lower his arm!'

(below right) Statues of notable men of the city's Victorian days line either side of the hall. Joseph Mayer (1803–86) was principal founder of the Liverpool Museum.

(below) Beneath the organ balcony is an exposed section of the exquisite Minton tiling that is elsewhere covered by a wooden floor.

'It might seem that these sketches would take a long time, but in fact I've done them in no more than 20 minutes. In spite of their time limit, the *Watercolour Challenge* contestants should spend half an hour or so honing their ideas and organizing their thought processes so that they are clear about what they are going to do when they start painting.' Putting away her sketchbook, Jenny then teamed up with Hannah to discuss the contestants' paintings at the halfway stage.

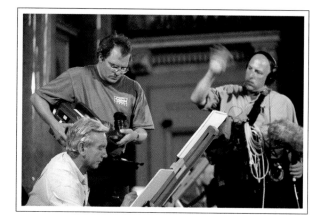

Rob Sargent keeps his camera trained on Bernie's painting, but the acoustics of the hall are clearly causing a problem for soundman Kevin Harper!

After lunch, with the contestants back at their task, Jenny discussed the tip of the day with Hannah, which was, needless to say, the importance of doing preliminary sketches. She then only had time to make a trio of colour note sketches because, in spite of the difficulties the interior location had engendered as far as sound was concerned, filming had gone well and there was a rare early finish to the day. While the team began to line up the easels for the prize-giving, Jenny explained the thinking behind the sketches.

'I've made three initial tiny studies to sort out what the colour balance would be,' she said. 'These can be worked up and used with other studies. The essence of the hall seems to me warm and calm and gentle, so I've decided to use different warm ranges to put that sort of glow across. I've just experimented, trying to keeping the colours fairly closely tied but using different ranges of them in each sketch. There's something slightly oppressive about the horizontal view looking down the hall, with its quite dark reds and pinks, and a more uplifting, soft and warm feeling in the composition with the large floor space. I used a strong purple for the background behind the organ to make that area recede a bit, keeping within a reddish range but making it bluer and darker in order to set it back a little, and put in a few brushlines to

In her colour sketch of a horizontal view of the hall, Jenny has given indications of the architectural details.

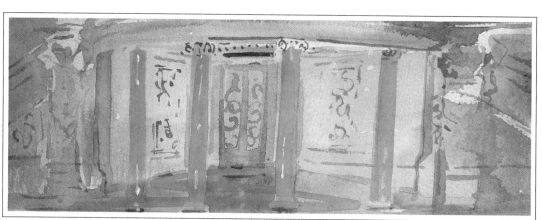

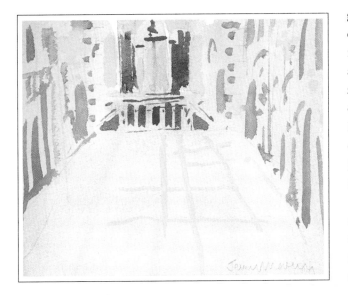

give the impression of the floor. The close-up of the organ is done much more wet-into-wet, but is still loose and exploratory. However, in the horizontal view I did start to work a little on top of the loose washes so that I'd have a bit more of an idea where some of the edges would start to come. I've just defined it fractionally more, making a suggestion of the patterns.

'At this stage I've got the drawings and the colour notes and it's just a question of making sure the balance is right before I can begin to put together a large piece of work on another day.'

(above) Warmer, more glowing colours give a more uplifting feel to the hall, with brushmarks on the large floor area leading the eye towards the organ.

(right) In the close-up view of the organ, the paint has been applied even more wet-into-wet than in the other colour sketches, giving a soft, diffuse effect.

CREATING PATTERNS

The art of creating patterns successfully in watercolour relies upon understanding the relationship of colours and also using wet and dry washes to achieve the desired effects. Rather than precisely delineating every detail, the aim is to keep freshness and spontaneity in the painting by varying the approach and leaving some work to be done by the viewer. Pedantically copying the pattern as it appears in real life will make your painting static and will possibly also make it the main point of focus, when your intention is actually to lead the eye to a different part of the painting.

A hard-edged pattern can be shown by using two colours of dissimilar nature and allowing one to dry before painting the second one next to it. The crisp edges given by applying the paint on to dry paper will be accentuated by the contrast between the colours.

In the case of two colours that are similar to one another, apply a wash of the paler colour first. Allow it to dry, then lay on the second colour, leaving the first wash uncovered to show the design you want. In this instance you are creating a pattern by what you leave out, with crisp but not hard edges.

A soft, diffuse pattern can be achieved by dropping in paint wet-into-wet so that the layer of paint already on the paper is moved by the application of the second colour. Experiment by laying a wash of a strong dark colour then, while it is still wet, dropping a pale colour into it. The soft-edged pattern that will result is harder to control than when you are working on dry paper, but by practising this technique and varying how wet or dry the paint is, you will discover how to achieve a more predictable result when you want to – although most watercolourists also enjoy the accidental effects that come with this medium.

If you want to describe a very strong pattern without it dominating your painting, use a combination of wet and dry washes to suggest some of the most important elements. By using this method you can create the essence of a pattern without it being so specific and focused that it monopolizes the eye.

Allowing one colour to dry before applying a second unrelated one next to it will create a hard edge, suitable for an unyielding surface such as a tile.

(left) Here the two colours are of a similar nature. Painting the paler colour first, letting it dry and then laying the darker colour on top creates a pattern as a result of what is left out. The edges are crisp but not hard.

(above) In this example, a pale colour has been dropped into a darker one while it is still wet. This has created a soft-edged pattern.

(left) Soft edges to a figure or sculpture give a more three-dimensional effect than hard ones.

(below) A combination of wet and dry washes here creates the essence of a pattern without making it too specific.

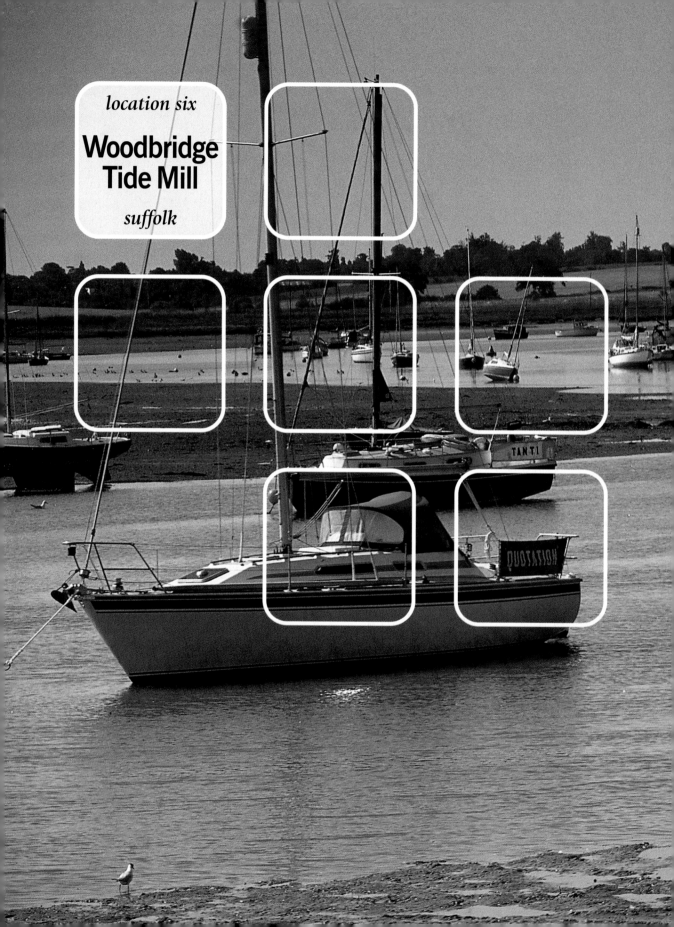

At a distance of little more than an hour's train ride from London, Woodbridge is separated from the metropolis more by era than by geography. To one side of the tiny station is a selection of cafés and restaurants, a swimming pool and a theatre-cum-cinema; to the other is the harbour. The atmosphere is of a British holiday resort before the advent of the motorcar, and although a short walk up the steep, winding streets brings you into the town proper with its handsome buildings and 16th-century Shire Hall, it is perfectly possible to have a good day out in Woodbridge without straying more than a hundred yards from the railway – which is exactly what the Watercolour Challenge crew and contestants did.

The harbour is dominated by the Tide Mill, and although the present building dates only from 1793 a mill has stood here beside the Deben since the 12th century. The pressure of the incoming tides opened the sluice gates and filled the millpond; as the tides began to retreat the outflowing water closed the gates, trapping the water inside. When the tides were at low ebb, the miller would open the sluice gates and the gushing water turned the millwheel and thus the millstone. The mill was operational for about two hours either side of low tide, so the miller's working day was an irregular one that depended on accurate timekeeping to make sufficient profit.

By the end of the 19th century the weatherboarding of the Tide Mill was beginning to deteriorate and the building was covered with corrugated iron sheeting, destroying a view popular with artists and photographers but preserving the mill from ruin. Its fortunes faded throughout the first half of the 20th century, and by the 1950s it was the last working tide mill in Britain. A diesel-driven hammer mill replaced the waterwheel in 1954, and in 1957 the huge oak shaft of the waterwheel broke; the 3 hectare (7.5 acre) millpond was sold for use as a yacht marina and it seemed as if the Tide Mill was about to succumb to the forces of modernity. In the nick of time, however, the Society for the Protection of Ancient Buildings began a vigorous campaign to save it. Its administration was taken over by the Woodbridge Tide Mill Trust and an appeal for funds in 1971 brought private donations and government grants. The roof and timber frame were repaired, the main machinery was restored, a new 5.5 metre (18 foot) millwheel was installed and a new millpond was constructed. In 1982 the new machinery was put to the test of the tide for the first time, with triumphant results. Now open to the public, the Tide Mill attracts visitors in their thousands and is once again a subject beloved of artists. The Watercolour Challenge contestants, lined up looking across the harbour towards it, were just the latest in a long line of painters to have studied its elegant form.

Irene Goodrich

Nigel Couzens

Carol Gyton

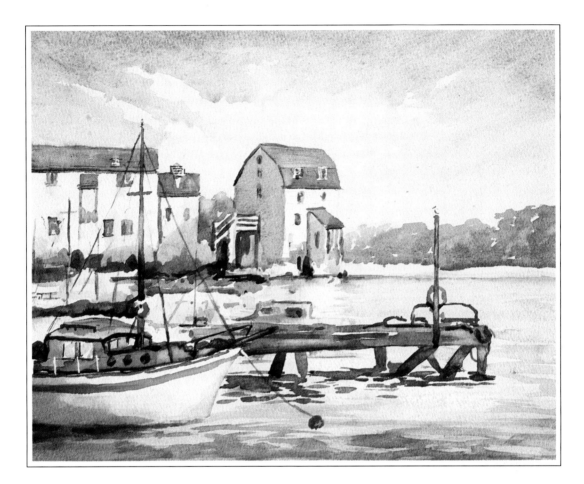

In Irene's painting the handling of the sky and the reflections in the water result in a calm picture that is full of light.

Irene Goodrich

Irene comes from a musical family, and as well as running a shoe-importing business with her husband, she has also taken part in many musical and oper-atic productions. Now her aim is to concentrate more on painting where, she says, she is the equivalent of composer and performer rolled into one. She does not belong to any art societies or attend any painting courses, and says she has learnt much of what she knows by watching *Watercolour Challenge*.

Water is one of Irene's favourite subjects, so she chose to paint the scene at high tide. After doing a couple of tonal sketches to plan her composition she laid a wash of raw sienna on the sky, allowed it to dry and then applied a wash of cobalt blue mixed with cadmium red, leaving lighter sky around the mill to draw the viewer's eye to it. Her water was put in with cobalt blue mixed with cadmium red to echo the sky, with added washes of transparent yellow to give greater depth and emphasize the reflections.

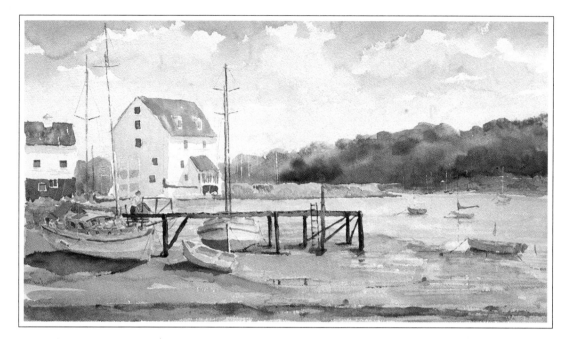

Nigel Couzens

While he was good at drawing in his schooldays, Nigel took a long time to come to painting and it has only been in recent years that he has started to put his interest into practice. He is a self-employed builder but plans to retire in just 18 months' time, buy a motorhome and paint his way around Europe.

At Woodbridge, realizing that the tide would come right in during the course of the day, he made one or two sketches to work out from the start how much water he would include. Deciding to paint the tide halfway in so that he could include both mudflats and water, he began by putting in the sky with one wash and then gradually worked down the painting. Whether he is painting inside or out, he always uses the same palette of three blues, three yellows, light red, Payne's grey, yellow ochre and burnt sienna. His traditional watercolour of the Tide Mill is notable for its delicate treatment of the water and the boats upon it.

(above) Nigel took a traditional approach to the subject, using a palette with which he is very familiar to achieve delicate and subtle effects.

(left) Once facing ruin, the Tide Mill has now been immaculately restored and is a popular tourist attraction.

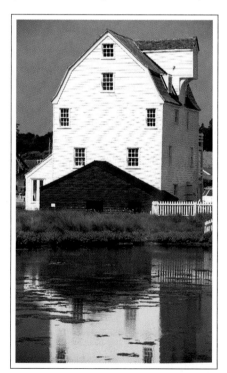

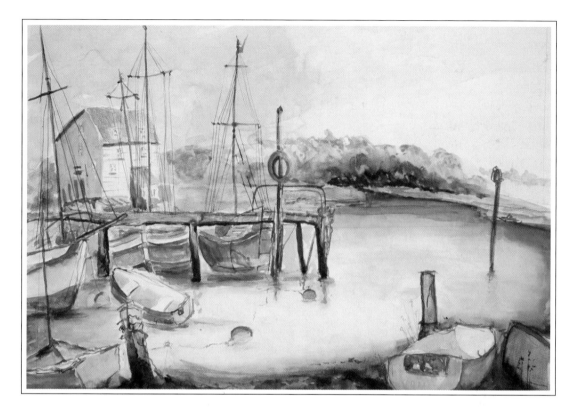

In Carol's lively painting, the busy scene of boats on the left is contrasted with a calm passage on the right.

Carol Gyton

Carol is a project manager in a counselling and befriending service. She has painted all her life, using a variety of techniques and media, and her influences include Van Gogh, the French Impressionists and Francis Bacon. However, her style of painting on any given day is directed by her mood and the subject. Buildings and boats do not figure among her favourite subjects and she often paints from her imagination, so finding herself on location with numerous vessels and a mill in front of her was quite a challenge.

She began by doing a loose sketch and, as she tried to find her approach to the subject, decided she liked the bustle of the scene to the left compared with the calm passage on the right. Laying wet washes for the sky, water and trees first, she then built up her painting, using light red, raw sienna and yellow ochre for the boats. For her final steps she used a rigger to put in the masts, and added some calligraphic strokes here and there to create an untidy, busy effect.

After weeks of rainy and sometimes downright chilly weather, the sun came out and temperatures climbed as *Watercolour Challenge* reached Suffolk. Hazel Soan, stepping out of her car on to the quayside at Woodbridge, took one look at the blue sky and the boats beached on the glistening mud and dived into the boot for her painting kit. Long before the contestants had reached their easels, she was ensconced on a jetty and well on the way to finishing her first painting of the day.

'There's such a lot I want to paint here and I've particularly got my eye on that yellow crane at the far side of the quay,' she said. 'But that will wait and this painting won't. The tide is rising and the early morning sun will move round, and if I don't catch these mudflats with the sun ahead of me now I'll have lost my chance for the day. I just love that mud with its pinky tinge; in a photograph it would probably look just grey or brown but the pink is definitely there. Where the water is running in it is really dark compared to the glittering mass of mud, and as I'm looking into the sun the topsides of those little vessels sitting tilted on the mud all have dancing highlights. I've painted the sparkle on the mud by using dry brush technique, though in fact the paint was quite moist. What I did was drag a No. 12 brush across without pressing it down, just skimming across so that the tooth of the paper would refuse the paint, and then increased the pressure to make the paint become solid towards the end of the brushstroke. It was the lightness of the stroke rather than the quality of the paint that made it a dry brushstroke.

(above) Hazel Soan paints swiftly and prolifically and still finds time to have a chat, here with Jill Robinson.

'Obviously, you can't reserve white space using that technique so I used masking fluid on the tops of the boats. When I rubbed it off they looked a bit blobby here and there, so I just touched them in and also put in a few tiny

(below) From where they sat, the contestants gazed across a melée of boats and masts to the Tide Mill.

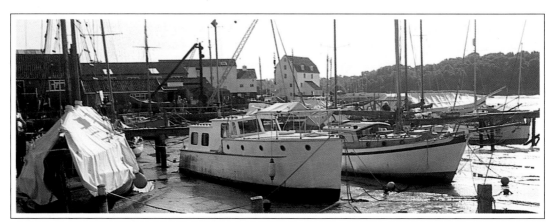

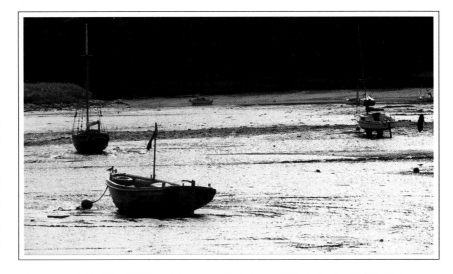

(right) At low tide in the early morning, the boats lay beached on glittering mud.

(below) A varied mix of Prussian blue, Indian yellow and quinacridone magenta gave Hazel a range of subdued colours in this tonal sketch of the mudflats in early morning.

details on the top of the decks. I use only a few colours when I'm working quickly, and my palette here was just Prussian blue, Indian yellow and quinacridone magenta. Where there's a red boat I've increased the magenta in the mix, but they are all quite dark because I'm looking into the sun.'

Putting that sketch aside, Hazel began to paint a coil of rope that lay on the jetty just in front of her. 'I love little details,' she said. 'The twists and turns of this

rope are just the kind of thing I can't resist painting. I'm doing it very simply with just a few washes, using a No. 9 sable brush with a good point that gives me the linear shape of the coil and then pushing down the body of the brush to make the spaces in between. In this location the light is going to change and the tide will come in and out, so it's quite enjoyable to do a quick painting of something that doesn't move!'

She had just finished her sketch when she was summoned to film a discussion of the day's challenge with Hannah. Picking up her gear, she hurried off to the place chosen for the filming – and it was conveniently near the yellow crane she had marked out as a subject when she first arrived. As soon as she was left to her own devices again she reached for her palette.

(above) Using just one brush and three pigments – raw sienna, French ultramarine and a little sepia – Hazel painted a quick sketch of a coil of rope.

(below) In this sketch of a crane, Hazel has made no attempt to establish tonal relationships and has instead concentrated on the feeling of activity on the quayside.

'This is just a bit of fun,' she said. 'If you half-close your eyes and look at the first painting I did there is a sense of distance given by the use of tone. This one is a jumble of tones that doesn't really make sense, but I'm not trying to make a picture here – it's a little colour mosaic of the activity, a piece of humorous narrative. I've just picked up the colours that are already in my palette as there's not a great deal of any one colour. I painted the crane first then decided that putting in a blue sky around it would ruin it, so I've just left the paper white.

'The contestants all have to sit facing the Tide Mill, but I don't – I've walked around and found the crane, the glittering blue water and the rope as well. It's a matter of using the whole scene to discover myriad subjects and then painting them in a different way. And after lunch, if that bicycle is still propped up on the jetty . . .'

It was. As the contestants settled down to the second half of their allocated time, Hazel also set to work. 'Again, if you half-close your eyes the tones don't work brilliantly in this painting, but it's just another sketch of an incident that for me sums up boatyards – there are always bikes on jetties and there's always a rope nearby and boats in the distance! I like to come away with paintings that sum up the day for me in a humorous way, and I think bikes have something intrinsically humorous about them. This is

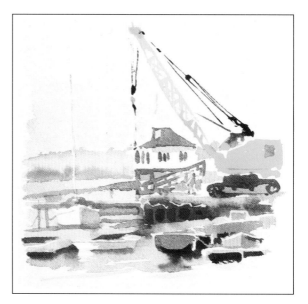

another piece about narrative rather than mood; it isn't trying to be a clever painting. Obviously you are always thinking as you mix colours, but there's not a huge amount of intellectual activity involved in it. It's a kind of memory painting, a diary sketch to keep for yourself. Actually, such sketches often have more life than anything else because you're not trying to impose too much on them.

'There are only very few colours again: indanthrene blue, yellow ochre, alizarin crimson, and a touch of cadmium red and cadmium yellow on the distant boats. I did a pencil sketch of the bike so that I could reserve white paper for the wheels and handlebars, but the rest was done without any sketching. Because it's only a tiny painting it's easy to work all over the paper, so the sky was washed in with a combination of alizarin crimson, yellow ochre and indanthrene blue and I continued that wash right down to the bottom of the mud, adding a bit more pigment as it came down. I left out a tiny strip for the yellow ochre of the distant grass, which was then put in before the first wash dried. The jetty was painted very quickly, leaving out the spaces between the wheels, then I plunged in the colour of the boats. I had to wait for it to dry before I put in the background trees, but even so it's a very, very quick painting.'

Hazel now embarked on her own interpretation of the Tide Mill, which stood bathed in sunlight and reflected in the blue water of high tide. 'This is a very complicated and cluttered scene. There's a plethora of images in there, all of which I want to paint, but you can't put everything in one painting without overdoing it. Sometimes it's a help to make little sketches that simplify a subject,

A suggestion of shadow crossing the planks of the jetty anchors the bicycle to the ground, while the red rear reflector echoes the colour of the boats beyond.

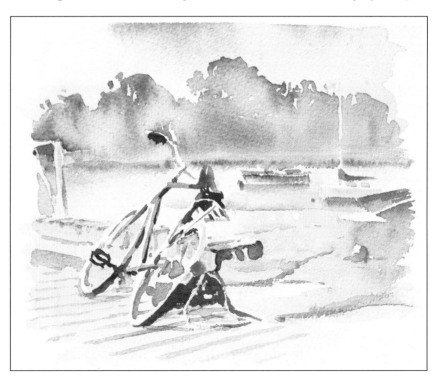

and looking across at that white tide mill I picked out two of the boats floating on the water at high tide. I reserved white paper for the masts and rigging as I ran in the blues of the sky and water. It's a very compelling atmosphere; the painting is really about that blueness broken up by whites, and of course the orange roof of the mill makes the blue stand out because blue and orange are opposites on the colour wheel. Whenever you can use colours to enhance each other you should look for that, but the Tide Mill is a dream, really – it simply offers the colours to the painter. I've made it a little more orange than it is in reality, but that's the sort of adaptation an artist does automatically without really being aware of it.'

As the contestants worked on their final touches and the tide began to ebb again, Hazel found time to paint one last sketch, this time taking a closer look at the boats. 'If I had been one of the contestants I wouldn't have painted the wider view. I like this lovely deep darkness between the boats and jetties and that would definitely have been my choice for a finished painting,' she said. 'Watercolour is wonderful for dark, mysterious corners because you can pick a few colours, mix them all together and then vary the mix. This

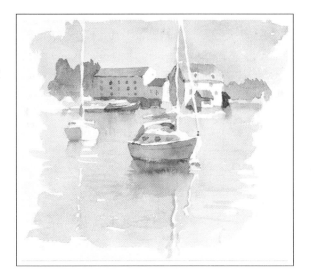

(above) Using Prussian blue, alizarin crimson, burnt sienna and yellow ochre, Hazel painted a sketch that summed up the mood of the glorious summer day.

(left) In her last painting of the day, Hazel switched her attention from the wider view to the dark shadows between the boats.

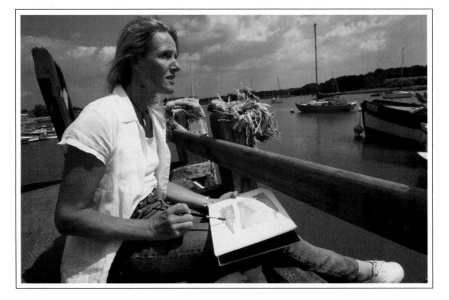

(left) With blue sky above her and blue water ahead, at least one of Hazel's paintings began with washes of blue pigment that covered nearly all the paper.

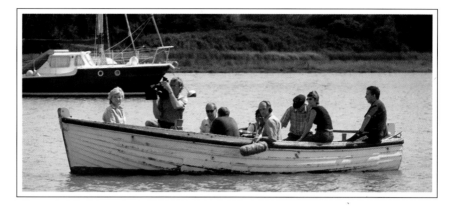

Hannah and a camera team take to the water, something that occurred several times during the third series but not always in such beautiful weather.

sketch is done in French ultramarine, alizarin crimson, sepia and yellow ochre, with a tiny dash of coeruleum for the turquoise blues. Only the coeruleum has been used pure – the rest are all mixed with each other in lesser or greater proportions. All you need to do is load a nice fat brush and plunge the paint in so that the washes run together. Much of this was done wet-into-wet; the background was all done with one wash, adding more red, more blue or more ochre as it came down and through. I let that nearly dry and then rinsed off the brush and put in yellow ochre with really swift brushstrokes. When that was dry I painted in the pinky colour of the hull of the boat. This sketch was done with big brushes in rushes of time.

'With a small painting like this you don't have to hurry as it won't dry too quickly. Mind you, that depends on conditions. Today it's hot and the paint is drying fast. My advice for such days is to work smaller – don't create problems for yourself. On a cooler day you can work bigger; on a damp day the paint will take forever to dry, so use less water or you will be waiting for ever. Alternatively, do a bigger painting so you can be working on other areas while you wait for one to dry. Paintings can easily be ruined by impatience.

'Including mixing the paints and waiting for them to dry, this sketch has taken 30 minutes, and of that time the brush has been on the paper for some seven minutes. Most of the process of using watercolour is watching paint dry, which is why I advocate what I call impatience paintings – something to do on the side, otherwise you wreck the picture by fiddling with it because you want to be painting. You can't turn the page because the paint's wet and often you can't put it down because the wind will blow it away, so you really have to sit and twiddle your thumbs, and it's very frustrating. I like sketchblocks because you can put them down beside you without worrying about them blowing away or flipping over, and you can do your impatience painting while you wait. Restraining the urge to fiddle with a painting is the most important thing, and I think it's helpful to paint lots of sketches before you start on a big painting so that you've got some of the urge to paint out of your system. I just love holding a brush and I'll even decorate the house sometimes because I have to paint!'

USING MASKING FLUID

Leaving white paper exposed to bring light and sparkle to a painting is part of every watercolourist's technique. Where possible, this is best done by simply reserving the white paper as you paint because the edges left by the paintbrush will always be crisper than those that remain after masking fluid has been rubbed off. However, masking fluid is invaluable for picking out details such as boat masts, allowing the artist to lay broad washes without interruption, or for dancing lights on water where there is a risk that they might be lost using dry brush technique.

Masking fluid is only there to help you reserve white paper while there is a chance that paint will go over it, so take it off as soon as you no longer need it. It is a common mistake to leave it on until the end of the painting process, but this creates an imbalance in your tones as it is yellow, not white, and until you can actually see your white paper you cannot accurately build up your relative tones. You may also find that the white areas are too large and need adjustment; even when it is applied with a fine brush or a pen, masking fluid can leave rather blobby marks. These can be remedied by simply crisping them up with a brush.

On a hot day, if the sun has been shining on your painting for three hours or more, masking fluid may melt into the surface of the paper, especially if it is a soft one. It may then slightly tear the surface of the paper as you rub it off. This can be used as a textural effect, but if you wish to avoid this happening try to take the masking fluid off as soon as possible.

Hazel Soan has developed her own method of using masking fluid for textural effects, a technique she hit upon when making textures for spray painting. After allowing the masking fluid to dry she scuffs it with a putty rubber before laying a first wash of paint. After this has dried she scuffs the masking fluid again and then applies more paint. Depending on the texture she wants she repeats the process up to four times, eventually reaching an effect that resembles marbling. This creative use of masking fluid can produce a range of broken textures that are ideal for subjects such as foaming water.

1 Here, masking fluid was painted on to the topside of the boat and the buoy and on some of the water area before the initial washes were applied over the whole surface.

2 Once the boat was painted the masking fluid was rubbed off, leaving a slightly blobby edge.

3 In the final stages of the sketch the highlights were tidied up with a brush to give a neater, fresher finish.

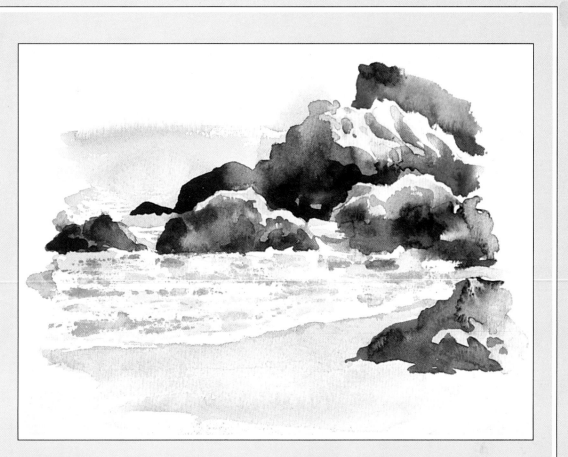

(above) In this sketch of a coastal scene, twice-scuffed masking fluid has been used to evoke the foaming water.

(left) Here an initial layer of masking fluid has been scuffed and a wash of paint has been put over the top.

(below) In this example, the masking fluid has been scuffed for a second time after a first wash of blue paint has been laid down. A wash of green has then been applied and allowed to dry before the removal of the remains of the masking fluid.

(right) A first wash of paint has been laid over masking fluid that has been scuffed once. After it has dried the masking fluid has been scuffed for a second time.

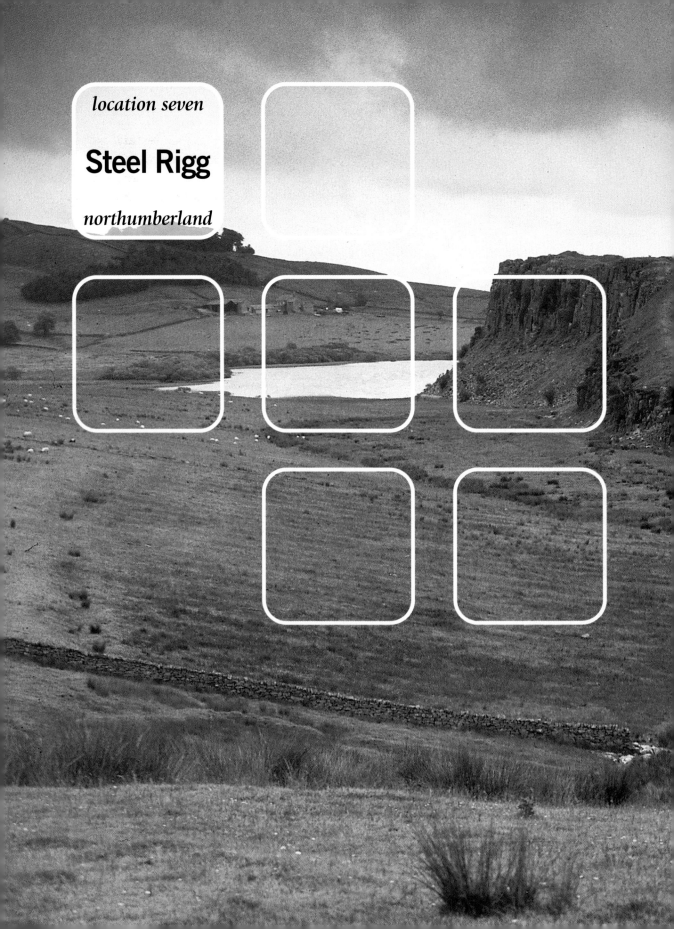

location seven

Steel Rigg

northumberland

The Roman Emperor Hadrian arrived in Britain in AD122, four years after succeeding Trajan to the imperial throne. The empire's days of expansion were past, and indeed retraction had already begun on its eastern flank. Britain was proving troublesome, and a revolt in the north in AD119 had resulted in heavy casualties for the Roman army, then based in a network of auxiliary forts. Nevertheless, the country was economically valuable, and the decision was made to undertake the costly and time-consuming labour of building a wall that would cross northern England from the Solway Firth to the mouth of the Tyne and keep the barbarian hordes at bay.

It is not known exactly when the wall was begun; Hadrian's biographer wrote that it was planned during the emperor's brief visit to Britain, but archaeologists believe that a start may have been made in AD120. Neither is it known for sure whether the idea was inspired by the Great Wall of China, though the similarity in the structure suggests this was likely. What can be established is that it took six years to build and measured 80 Roman miles (117km/73 miles) long, with 76 small forts along its length about 1 Roman mile apart. Now called milecastles, these forts housed the patrol garrisons and were supplemented by watchtowers and larger forts for auxiliary regiments. In typical Roman fashion, the wall was built in a straight course with no attempt to avoid either high or low ground, and at Steel Rigg it runs down a hill and then steeply up and along the top of the dramatic rocky escarpment in front of which the Watercolour Challenge umbrellas were set up.

Today, Hadrian's Wall is a World Heritage site. It is considerably smaller than its original height of about 5 metres (15 feet) and, in the stone sections, breadth of 3 metres (10 feet). Two million tons of stone went into its making, and in the 31 Roman miles of Turf Wall, turfs were cut to 45 x 30 x 15 centimetres (18 x 12 x 6 inches) and laid to create a barrier that was 6–7.6 metres (20–25 feet) wide at the base. To the north of it was a great ditch, in places nearly 12 metres (40 feet) wide and 3 metres (10 feet) deep. The whole structure was an unmistakable message to the barbarians on its northern side that the Romans controlled their access to any benefits that the empire might offer, while the rebellious Brigantians in the Pennines to its south were imprisoned within the province, cut off from their northern allies. The wall was the greatest feat of engineering that the Romans accomplished in Britain, and was intended to quell resistance by its very presence as well as by the unparalleled opportunity it gave its troops to keep a close watch on any movement in the surrounding countryside.

So would the wall also daunt the Watercolour Challenge contestants, 2,000 years later? From where they sat, the towering escarpment reared up in front of them in a central position, creating a number of compositional choices. Then, too, there was the matter of portraying the atmosphere of the wild landscape and the ancient stones. The location called for an emotional response to its history as well as careful handling of perspective and scale.

Liz Harrison John Gardner Pamela Stott

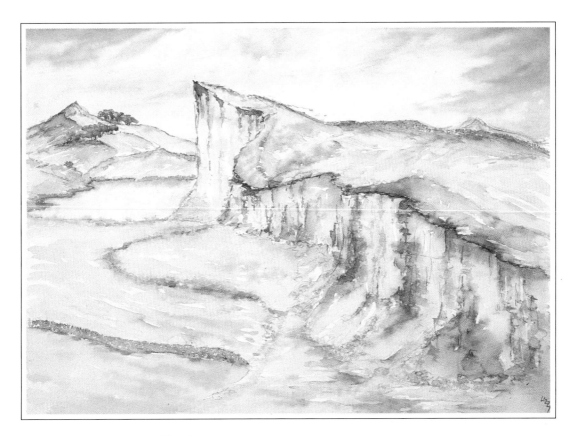

In Liz's painting, the rising diagonal of the hilltop adds drama to her composition and gives a sense of rhythm which is echoed along the rockface.

Liz Harrison

Liz is a school secretary. She has been interested in arts and crafts for many years, and her particular fondness for watercolours eventually prompted her to take up painting four years ago. Moody skies and interesting landscapes are what appeal to her most, though she enjoys architecture for the challenge it poses. Her style tends towards the traditional when she is painting buildings, but with landscapes she paints in a looser, freer style and likes to be creative in establishing the elements of her composition.

At Steel Rigg Liz was most attracted by the craggy rocks and the water, and decided not to make much of the wall itself. She warmed up the grey day by picking out the pinks and ochres she distinguished in the rocks and sky, providing contrast to the blues in her painting. By exaggerating the lift of the hill from the horizontal to the diagonal, she injected a sense of drama that was well suited to the subject. The wall, although a relatively insignificant part of her painting, was drawn in with a pen to lead the eye into the picture.

John Gardner

As he is an architect, John has no trouble in executing an accurate drawing, but when painting he prefers to work in a looser style than is possible in his professional life. Landscapes, water, boats and buildings are favourite subjects and he enjoys experimenting with different means of applying the paint, using feathers and sticks to achieve different textures.

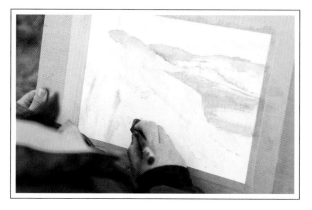

John began his work at Steel Rigg by making small thumbnail sketches of the main features before deciding to contrast the distant man-made buildings with the irregular, organic rockface in the foreground. He started the painting process by covering the whole paper with raw sienna to banish its glaring whiteness, then laid down washes of Payne's grey mixed with a little light red for a gloomy sky. Next he built up washes of varying intensity to create a sense of depth from the barely described background to the rocks in the foreground, putting in the fissures in the rockface with a rigger and a small flat brush and using the same two colours that appeared in the sky, this time employing a greater proportion of light red to achieve a warm dark brown.

(above) The early stages of the work on the rockface in John's painting, with the landscape washed in behind.

(below) John decided to contrast the buildings with the rockface. Although his use of soft areas in the foreground and hard ones in the distance breaks the rules, the relationship between them works well.

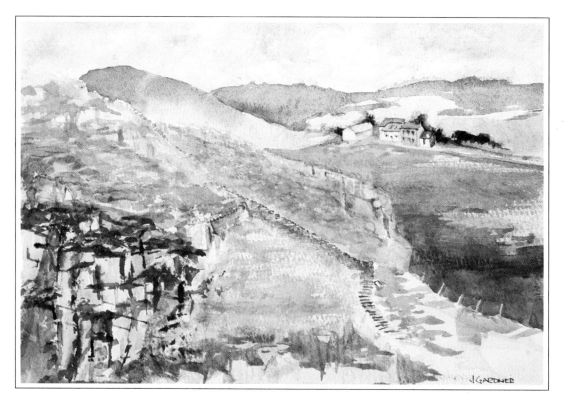

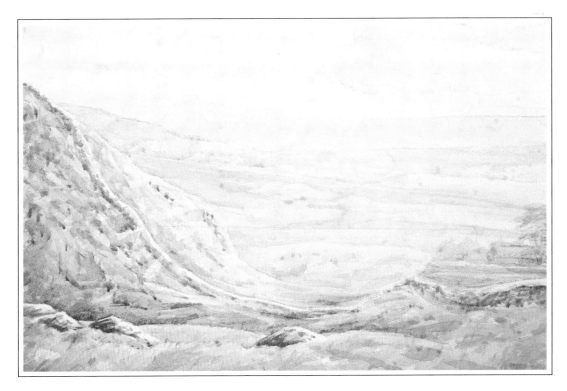

Pamela's soft and lyrical view of the landscape makes use of dilute washes where little is explained but the viewer's eye is drawn to the expanse of moorland.

Pamela Stott

Pamela studied Fine Art at Edinburgh and subsequently worked in the library of the city's Gallery of Modern Art. She now runs a mobile library in Billingham. She has been painting in watercolour for 15 years, and the vastness of the moor at Steel Rigg allowed her to make the most of her technique of gradually building up a picture by means of very dilute washes – a contrast to her work in pastels, when she goes straight in with deep, dark colours.

Rather than painting the rockface directly ahead of her, Pamela chose to concentrate on the moors stretching away out into the background. She put in the sky first, because the light was changing and she wanted to capture the dark clouds moving across the sky; next she worked from the distant hills to the middle distance, putting darker washes on top to model the landscape, gradually working her way down to the foreground field. She left the hillside and Hadrian's Wall until last, wanting to put them in with a darker tone without upsetting the tonal balance of her poetic view of the landscape.

Although it was July, a biting wind was scouring the broad expanse of landscape where Hadrian's Wall snakes across the Northumberland National Park, and Mike Chaplin sat hunched in one of the contestants' chairs in the early morning light with his collar pulled up around his ears. He was already at work on a sketch of the rocky escarpment ahead of him, using a pencil to block in the tonal values.

'This is a difficult composition for the contestants,' he remarked. 'They will need to pinpoint one or two areas of specific interest, then everything else in their painting should support those. Some areas will have to be quite defined and others quite loose so that the artist is in charge of directing the viewer where to look, which in my painting will be the light on the hillside.

'The sun is almost ahead of us, albeit hidden by cloud, so I'm seeing everything against the light, which reduces it to very high areas of contrast. The light is hitting the top of the distant ridge, creating an area of light acid green, and just to the left of that is the cold, very light grey of the sheet of water. They are two very high, strong tonal points, and my idea is to set them

(above) In a preliminary pencil sketch, Mike worked out his composition and the tonal relationships within it.

(left) The art experts are used to having to scramble out of the way of the cameras, and here Mike makes do with a patch of damp ground to work on.

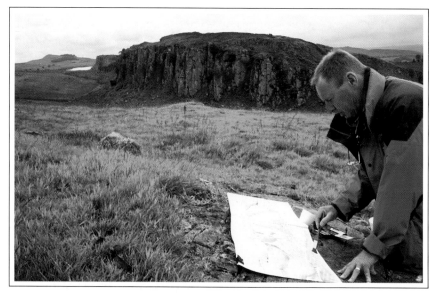

into a slab of the very dark tone of the landscape with the little linear elements hidden away. That's basically what my drawing is about, with the main area of interest in the top left-hand corner. It's the relationship between the water and the acid green light on the hilltop that interests me – the two areas are similar in size, but one is about colour and the other is an extreme of tone. There's a subtle compositional balance between them. The very dark tones just underneath the light will be very important in the painting, as they will make the light shine out strongly.'

The contestants arrived to claim their chairs and Mike moved to a vantage point on a nearby rock. There he perched in some degree of discomfort to finish his sketch, keeping a wary eye on the herd of cattle, including a bull, which roamed free within a couple of hundred paces of the umbrellas. What with the cold and the bull pawing the ground the day didn't look promising, but Mike, with a previous series of *Watercolour Challenge* under his belt, was accustomed to toughing it out if necessary. Once the sketch was finished to his satisfaction he set up his easel and began to paint.

'I started off with a loose wash of sky, then put in strong yellow as a colour note,' he explained when he paused for a break. 'Next I drew with dark tones around the yellow to see how bright it needed to be. I like to make one or two notes early on about the extremes of tone, so although it's a good idea from a technical point of view to lay in the loose background washes, I usually make one comment on the paper about the very darkest tone I see in the landscape. That way, I can see whether I've got the initial washes the right tone. This is important, because you can't come back to them later on and make them darker if you've got subsequent drawing accumulating over the top. Washes are going to dry lighter anyway, and it may be that when you put in darker areas of drawing subsequently you decide that those first washes could have been much stronger and darker to give the painting more authority. However, you don't know what the relationship is going to be until you've got that dark drawing over the top. That's why when I put on the first washes I put somewhere in the painting the very darkest tone just so that I can judge whether I've got those washes strong enough.

'I'm going to make the whole thing darker and darker in an attempt to make the light really shine on that hilltop. I don't mind if I wreck it – I just want to satisfy my curiosity about how much I

Mike's initial colour washes, with acid yellow showing where the light hits the top of the escarpment.

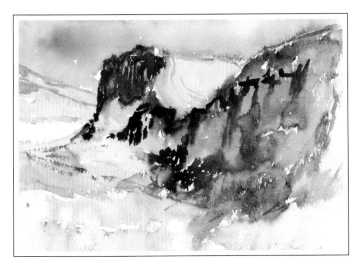

can make that light shine out there. I'm not painting to create a finished picture, I'm painting to find out something about that bright yellow patch. I'm going to let it dry off and then see if I can put any more drawing back into it, because the drawing has disintegrated a bit under the washes. It's getting a bit out of hand because it's too wet.'

Although the air was damp, the sharp wind dried the painting quickly and Mike was able to take a fresh look at it. 'I've made the yellow on the ridge too light and too acid. It needs to be cooler and more distant, so I may put a light greyish-blue wash over it to see what that does to it.'

He had propped up the paper at an angle of 15 degrees to encourage the grains of the pigment to accumulate in the roughness of the paper, giving a slightly granulated appearance to indicate depth and texture in the foreground. 'Most of the Victorian watercolours had granulation because the paints were ground by hand, not by machine,' he said. 'Now they are ground exceedingly fine, but a natural earth colour such as burnt sienna or nearly all of the cobalt colours, which are refined from a mined ore, tend to have a grit size we can actually see. If you're using them in a very wet state on a paper that has a grain to it, and particularly if you have that paper at a slight angle, the water deposits little grains of pigment into the roughness of the paper as it travels down. You can use this as a very subtle textural device. If, for example, you wanted to show the difference between a cool area of shadow in the foreground and the bluey tinge of a very distant sky and landscape, you might use a blue that doesn't granulate for the sky, but will instead dry very flat and lie back in the picture.

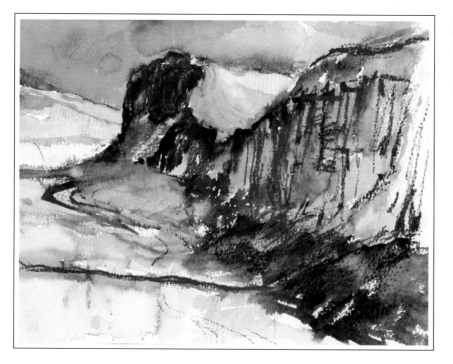

A greyish-blue wash cooled and muted the yellow on the ridge, while darker tones below it ensured that it still stood out as a focal point in the painting.

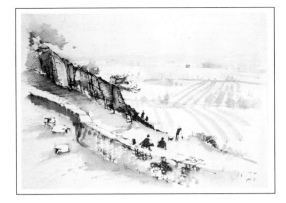

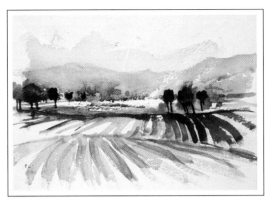

(above) In this pen and wash sketch, the figures emphasize the huge size of the rockface and also give scale to Hadrian's Wall.

(above right) Blue-toned paper gives recession to the distant landscape, where a drift of white smoke indicates human activity.

If you then put a cobalt blue that will granulate slightly in the shadow in the foreground, it will provide a bit of texture, indicating that it is closer to the viewer. I use granulation as a textural device to subtly establish a spatial relationship on the paper.'

Having explored the possibilities of the rockface, Mike turned his attention to the moor stretching away to the south and east of it, which both Pamela and John were including in their paintings. Using blue-toned paper, he made two quick sketches, the first one using a fountain pen, some clean water and just a dash of watercolour.

'In the case of this pen sketch with figures in it, the blue-toned paper isn't relevant – it just happened to be to hand. Here the aim is to establish the scale of that huge rock. I wouldn't make the figures so specific if I were going to add

them to a painting. This is quite an illustrative little pen study of people who happen to be walking along, but I think in a real painting they would be reduced to something much simpler to prevent them from introducing too much narrative. I would want the painting to be mainly about size and scale and space; you could use the figures to show narrative, but that would detract from the power of the rock because the picture would become about storytelling. I would just put in little dots of colour, like those two figures climbing up the rocks – you can't really tell who or what they are, but they give scale to the whole rock.

'In the second sketch the blue paper represents a cool blue wash that could be laid on the paper for the recession of the distant landscape. It reinforces the sense of its remoteness. I've put in a drift of white smoke to bring human interest into what is quite a desolate landscape. It's by no means explained, but it introduces a sense of movement – and a sense of warmth, which I probably feel in need of at the moment!'

FIXING A POINT OF INTEREST

In a successful painting, the viewer's eye is led to the area that the artist has chosen as the main focal point. One way of achieving this is to use a combination of hard and soft edges, the hard ones attracting attention because they are sharper and contain more detail.

At Steel Rigg, Mike began a sketch in very broad panoramic format where at first glance there is an obvious composition with the rocky outcrops forming the main interest in the middle. As he continued to work on it, however, he became intrigued by the double perspective of the landscape on either side of it and decided to balance these two different viewpoints against each other and subdue the dominance of the rockface.

To manipulate his hard and soft edges, Mike chose to use charcoal and a brush to draw with, the brush giving a harder edge to the shapes. Some of the lines can be seen overlapping in the texture of the rockface, where the overlay of hard and soft lines gives an impression of depth that would be absent were all the lines drawn at the same pitch.

On the right-hand side of the painting, the landscape seen beyond the escarpment is rendered with wet-into-wet washes and is softly drawn with charcoal. On the left, the landscape is drawn as a series of washes, one on top of the other after each has dried off, so the edges of the shapes are quite hard and defined. The result is that the viewer's eye wanders back through and round the right-hand side much more than the left, because it is softer and much less explained.

Charcoal is an excellent medium for providing a strong line, and it can be manipulated to produce harder or softer edges. You can fix it to prevent it from smudging, in which case it will remain a hard line when paint is washed over it. Alternatively, you can wash over it without fixing so that the line deteriorates and softens. The viewer's eye will be directed first to the areas in which there are harder edges. Mike's advice is that hairspray is fine for sketchbook work, but proper charcoal fixative should be used for a finished painting.

Here charcoal was fixed on the left and then used for more drawing on the right, which was left unfixed. When paint was washed over the whole, the lines that had been fixed were retained while the rest of the drawing deteriorated into the wash.

①

1 Having indicated the main features of the painting with pencil, Mike began to lay washes of colour on the rockface and the landscape to its left.

2 Warmer colours in the foreground and recessive blues in the far distance begin to give a three-dimensional effect to the painting.

②

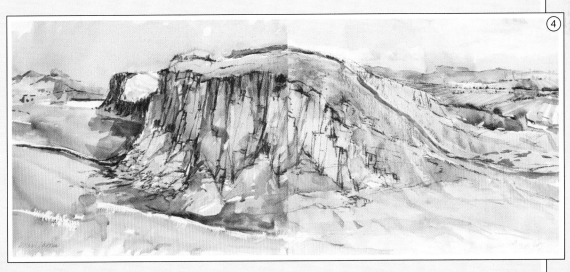

③

3 More detail has begun to appear in the rockface, where the fissures and textures are indicated with both hard and soft edges made by brush and charcoal.

4 Although the sketch was quickly done, Mike has directed the viewer's eye to where he wishes it to go by using a combination of hard and soft edges and cool and warm colours as well as by his use of perspective.

④

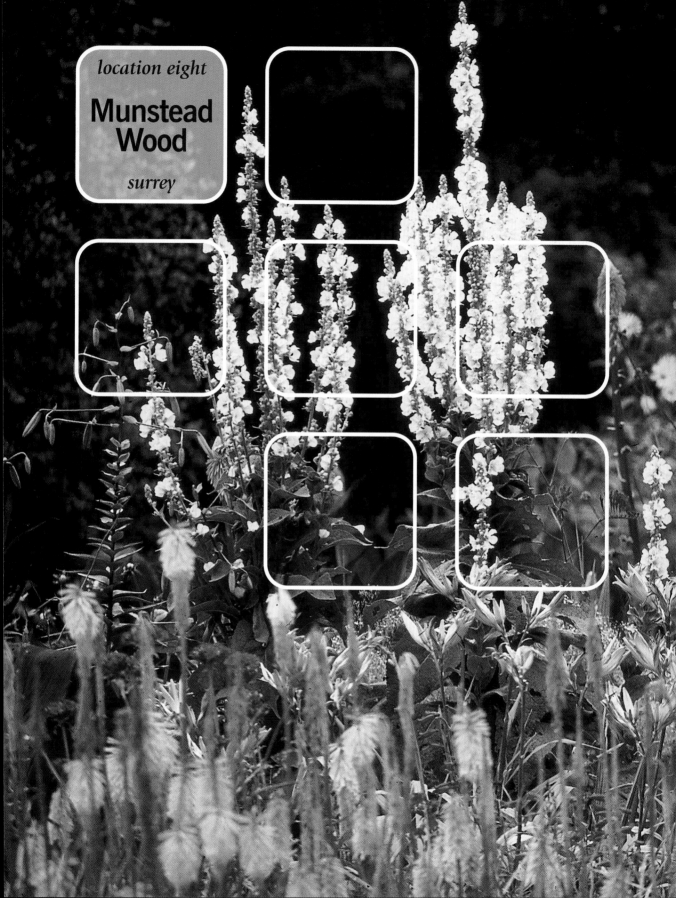

location eight

Munstead Wood

surrey

The garden at Munstead Wood is a lasting memorial to its creator, Gertrude Jekyll. One of the most influential garden designers of the early 20th century, she bought the 6-hectare (15-acre) plot of land in 1883 and began to plan and plant a magnificent garden that would take her 15 years to bring to fruition. Her design encompassed woodland gardens, a sheltered spring garden, a secret garden hidden behind evergreens and the famous herbaceous border that set a fashion throughout Britain. Measuring 60 metres (200 feet) long and more than 4 metres (14 feet) wide, it is designed with a colour scheme said to have been inspired by Turner's painting The Fighting Temeraire.

Miss Jekyll was born in London in 1843, and was allowed by her parents to attend art college – an unusual course of action in her day. After leaving college she mixed in literary and artistic circles and became acquainted with the Arts and Crafts Movement, which aimed to reassert the importance of craftsmanship at a time of increasing mass production. The members of the Movement, who included most notably William Morris, subscribed to an ethos of using traditional materials and, in the Arts and Crafts gardens, designing with regard to the natural habitat rather than imposing alien plants and forms.

The Victorian writer and gardener William Robinson, who advocated a return to traditional planting in place of the carpet bedding that had been fashionable, was a great influence on Miss Jekyll as she began to create her first garden in 1878 at the home of her family at Munstead Heath, near Godalming. In 1882 she began to contribute articles to his magazine The Garden, which led to her embarking upon a lifetime of writing the articles and books that made her a household name. Failing eyesight forced her to give up painting in 1891, when she threw all her visual energies into gardening and expanded her burgeoning career as a professional garden designer. In 1893 she began a partnership with the architect Edward Lutyens, who built her house at Munstead Wood, and together they created a series of exquisite houses and gardens that were to prove highly influential in British gardening up to the present day. Still busy with commissions in her eighties, Miss Jekyll died in 1932, having designed a total of 350 gardens.

Munstead Wood is now in private ownership and is open to the public on only a few days each year, so it was a rare privilege for the Watercolour Challenge crew and contestants to spend a day there with the gardens all to themselves. With the umbrellas set up facing the famous main border, the artists faced the challenge of handling their colours in a way that would do justice to a planting scheme that has blazed its way through a hundred summers.

Peter Lorimer

Patricia Burbidge

Mike Buckland

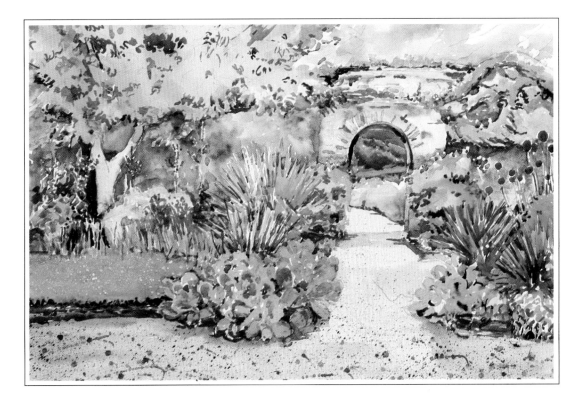

Peter brought foreground interest to the path by spattering colours that were used throughout the painting.

Peter Lorimer

Now enjoying an early retirement, Peter used to teach pottery in prisons and at adult education level. A set of watercolours was a retirement gift from his father, and he loves their translucency and immediacy. He attends Maidstone Art College one day a week and is a member of the Malling and Maidstone art societies. As Peter normally expects to spend eight hours on a painting, he put in some practice at halving his time in preparation for his day with *Watercolour Challenge*.

Trees and gardens are among Peter's favourite subjects, so he was more than pleased with the location and especially liked the way the yucca plants echoed the shape of the archway. He prefers to mix colours as much as possible on the paper, so he laid a loose wash on the wall and dropped other colours into it while it was still wet. Using darker and stronger tones towards the foreground he successfully established a sense of distance, and finished off his painting by spattering the path with colours used elsewhere to give unity and interest.

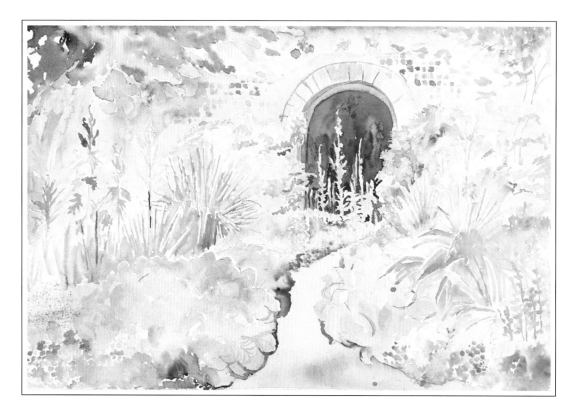

Patricia Burbidge

Patricia studied Art & Design at Portsmouth Art College and teaches art in London schools and at adult evening classes. She also belongs to the Richmond and Twickenham art societies, so painting occupies much of her life. Her work is loose and impressionistic, and she tends to establish a particular colour theme in each painting, applying pale wet washes and then building up the colour.

Feeling overwhelmed at first by the amount of colour at Munstead Wood, she narrowed her composition down to a small section of the garden. She finds it comfortable to paint kneeling on the ground, and she did this here so that she could see the flowers through the archway. She chose this area for her strongest contrasts, placing yellow verbascums against a dark background. Using a piece of embroidery mesh, she stencilled some flowers in the right of the foreground and also used the same technique on some of the brickwork in the wall. In a variation on this, she tore a hole in a piece of newspaper and spattered some paint to give texture on the left-hand side of the painting.

Patricia's use of stencilling and spattering added textural interest to her ethereal painting.

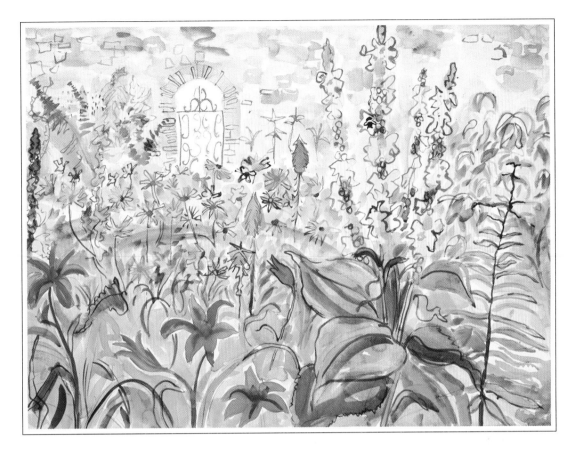

Exuberant colour and lively outlines show inspiration from Matisse in Mike's painting.

Mike Buckland

Mike attended art college in the Sixties and has painted ever since. He took up painting in watercolour ten years ago and considers it a good medium for portraying a direct response, although in his studio work he still uses oils. Mike's job as a postman allows him free time in the afternoons and he likes to head for the Chilterns to paint the landscape there in watercolour.

At Munstead Wood, Mike moved his easel over to the herbaceous border so that he could concentrate on the flowers. He began by putting in the vertical forms of the verbascums, attracted by the contrast of their cool yellow with the warmer yellows of the daisy flowers. He allowed the colour to flood beyond the flowers, then put in lively outlines with the point of a brush. From there he built up his painting using washes and line in conjunction, improvising a vertical plant on the extreme left to act as a stop to the eye and moving the archway to include it in his background.

As the contestants lined up on the lawn facing the legendary herbaceous border with the crew in attendance, Hazel Soan slipped quietly through an archway into the Summer Garden. There, with a high stone wall muffling all sounds of filming, she was able to paint in apparent solitude, drawing inspiration from a garden planted by another artist a century earlier.

When she reappeared for a break and a chat she was carrying two sketches, one only partially done. 'I was so excited by the colours that I got a bit carried away,' she said. 'With the first sketch I washed in great swathes of pigment in the beginning to get the colour banks of the flowers, intending to use the pinks and yellows of the petals to modify the greens that would come later. As I was painting, though, I realized that Gertrude Jekyll's choice of foliage in this garden is so considered that in many cases I would rather have left areas of white paper so that my greens wouldn't be dulled down by the underlying colour. Having laid down my colour, I had actually lost the opportunity of painting specific greens. This is very unlike any other garden I have ever painted. Her greens are

The contestants were given the task of painting Gertrude Jekyll's famous herbaceous border, designed to represent Turner's *Fighting Temeraire*.

so pertinent that you can't just go in with any old green; she's chosen plants as much for their foliage colour as for their flower colour. Some of the greens are very acid, some are very grey and others are very blue, so one's normal thought to use the petal colour beneath and mix the yellow and the blue in varying tones to make them either yellow-green or blue-green won't do here. You have to be quite specific.

'I decided that it was best to abandon that sketch altogether, but it wasn't a waste of time because I learnt such a lot about the garden while I did it; I admire Gertrude Jekyll so much for her brilliant blobs of colour and the brushstrokes of vertical flowers. I sat down again and distilled everything I had come to appreciate about the garden in this second painting. In the earlier one I painted the colours that were there in front of me, but here I've painted a combination of many things I saw, bringing in colours from elsewhere. I worked wet-into-wet, gradually building up background foliage to bring out yellow verbascums

(above) In the Summer Garden, fiery red crocosmias blazed behind dark pink penstemons, deep yellow verbascums and paler yellow daisies – a riot of colour that inspired Hazel to begin a vibrant painting.

(right) Hazel's first sketch – an apparently promising start, but one she abandoned. However, it was a learning experience rather than wasted time.

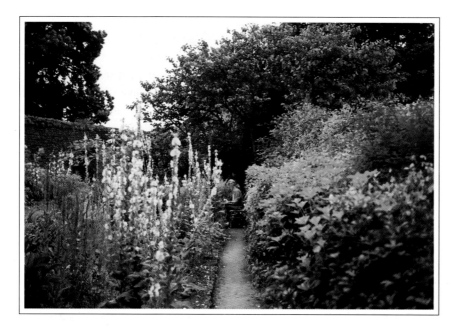

Separated from the crew by a massive stone wall, Hazel was able to paint in the peace of the Summer Garden.

and white flowers. This was a gentler approach than I used in the first painting, when I was so excited by the vibrant colours that I went crashing in with a riot of colour, but then realized that if I pursued it the end result wouldn't please me. It often helps to make a preliminary painting of a subject and then when you paint it again, you distil the things you really loved. I feel an incredible peace here and the second painting sums it up more; the other was what I thought I was seeing, but actually it wasn't. Both were started in a similar way with the colours running into each other, but the second has less excitement and a bit more control.

'I'm going to discuss the challenge of the location with Hannah now, but when I come back I shall indulge myself with a sketch that's all about colour. There are some stunning purple flowers in that garden planted in front of some yellow daisies. When you stand in front of them and half-close your eyes you just see yellow and purple, which of course are complementary colours.'

The chat about the challenge was filmed with Hazel and Hannah seated in front of the beautiful Lutyens house, and once it was completed, Hazel returned to the Summer Garden to do the sketch she had promised herself. 'Most of the flowerheads in this garden are quite humble, but they

In a second painting of the border in the Summer Garden, Hazel used softer, more diffused colours to describe the peaceful atmosphere.

(above) Using Indian yellow, quinacridone magenta, French ultramarine and ultramarine violet, Hazel painted an impression of a vibrant combination of yellow and violet flowers.

have the most amazing colour,' she said. 'They also have incredible comparative foliage colour – the leaves of the crocosmia are a perfect complementary green against the brilliant red of the flowers, but if you painted them like that you'd have the two colours vying for attention. The more I paint in this garden the more I realize how clever Miss Jekyll was. If I were an abstract painter I would just have painted colour splotches for this garden. The sketch that I'm doing now is an excuse to enjoy using really bright colours of violet and yellow – the subject matter isn't important.'

Laying that sketch aside to dry, Hazel began work on a very different subject. 'A sharp-eyed person who has come along with the crew today spotted this mossy piece of branch on the ground and thought I would like it,' she said. 'It sums up Munstead Wood for me because it was lying on the edge of the wood itself and I am so enjoying painting it. The green of it is yummy! It is little things like this that set me on fire. I love the fact that there are so few colours – that always excites me. It was a challenge deciding what to use for the green because I'm a great lover of aureolin and Prussian blue and I'm tempted to dip into aureolin as soon as I see a bright green, but green gold has come to my attention and I really like it. It is the main green here but there is still a splash

(right) A limited palette and a combination of washes and precise brushstrokes perfectly describe the texture and form of a mossy bit of branch found on the edge of the wood.

of aureolin – there was some in the palette and I think my brush just took itself magnetically there without my having any control over it! I've used raw umber and burnt umber for the darks, so really there are just three colours plus touches of aureolin and Prussian blue to bring in the shadows and cool off the browns in places.

'The interesting thing is that it tempted me to do every last and final detail, but when I began to put a wash on it I thought no, I want to summarize the ins and outs of this log, so that is what this painting is about. The velvety feel of moss has been given by varying the tone round the log. Rather than laying it evenly I did the wash in blobs to make a softer, more uneven texture, which is how velvet looks. But I didn't do that consciously; in all painting the seeing comes first, and if you see something and love it and paint with that affection and that concentration it's astonishing how often you create something like that velvet texture more by default rather than thinking about the technique needed to do it.

'The little layers of the surface are tiny brushstrokes lifted and dropped, using the point of the brush with varying pressure. They are deliberate and meaningful, describing the thickness of it. You don't fiddle about with specific brushstrokes like this. They are quick, flicky, precise strokes but if you get them wrong there's no need to worry because nobody will know exactly what the subject looked like.'

The next time Hazel was called through to the main garden, the old door in the archway caught her eye as she left. When she was finally able to pick up her paints again she just found time for another painting while the contestants worked towards their deadline.

'I love things that are old and weathered, and I think watercolour lends itself wonderfully to showing that because of the textures you can get,' she said. 'For this study of the door handle I used wax over the washes. I laid a big wash of pinky-yellow colour for the flowers behind the door over the whole area, just leaving out the little highlights on the studs and adding some blue to make it mauve as it came across the door. When it was dry I rubbed a household candle over parts of it so that there would be a rough, weathered look where the wax resists the watercolour. A bit of wax at the top of the handle just where the highlight was catching it ensured no paint would reach the paper there. I built up the dark blue at the side of the door to describe the edge of it, but I suddenly realized that

The use of a wax resist and a combination of wet washes and dry brushstrokes has given the effect of weathered wood and rusting metal in this sketch of the door to the Summer Garden.

Liberated from his seat under the umbrella, Mike paints the herbaceous border close up, unworried by Trevor Salmon's camera.

some of the door was darker than the background and other parts were lighter, so I came from the right-hand side with a merge of different colours brought across in downward strokes, some of them quite dry, to get the feel of the timber. I still left out the studs at this stage.

'I brought those colours right across to the flowers. Where I wanted light flowers I made the door darker against them and where I wanted darkness in the distance I made the door lighter. Then, when the paint was dry, I rubbed another layer of wax over the door in parts so that there would be another area held back from subsequent washes. I laid wet washes over the waxed areas and used some dry brushstrokes elsewhere. Finally, when that was dry, I painted the handle and studs. The shadowed edge of the door handle had been painted as I went along, but I used much darker pigment over that to bring it out from the door behind. I found that the studs tended to stick out a bit, so I did another wash on the door and touched in the undershadow of the studs to sink them back a little. I had great fun just slooshing paint around – it didn't matter exactly what I did. Drying takes the longest time. I spent 45 minutes on this painting, but I was laying paint on the paper for only 15 minutes of that time.

'I've had a great day at Munstead Wood. I've painted the brilliant colours of the border, and I've also done the kind of small subjects that could be found anywhere but will act as a reminder of this garden whenever I look at them. And now I shall go and see what the contestants have made of their day.'

FINDING THE ESSENCE OF A GARDEN

It is possible to evoke a whole garden in a painting of a single plant by suggesting its organic nature and the surroundings in which it is growing. Rather than treating it as a flower study in a still life setting, the aim is to paint an emotional response to the scene that will inspire a similar response in the viewer.

Using a large brush such as a No. 16, lay a first wash to show the overall colour of the view. Next, using a smaller brush and more specific colours, start to build up the background around the flowers you are going to paint so that you are leaving them out of the wash.

In the third stage of the painting you can look more at the individual flowers and begin to build them up one by one. Evaluate the time it is taking the paint to dry under the weather conditions of the day and take care to paint some wet-into-wet and others wet on dry so that not all of them are treated similarly. Make sure that, as always, there is a main point of focus, choosing one part of the painting for more detailed treatment that will lead the viewer's eye to it.

One of the pleasures of painting flowers is that you do not need to worry about detailed accuracy; no two are quite alike, so no one will be able to tell you in retrospect that you got it slightly wrong. It is far more important to enjoy laying the washes and to portray the life and energy of the flower rather than to try to tie it down with detail. However, in the final stage of the painting you can use a finer brush to strengthen parts here and there and to add little touches of colour to describe shadow or pattern.

(left) Hazel's model: a yellow verbascum singled out of the myriad blooms in the Summer Garden.

1 To paint the verbascum, Hazel first laid a wash of cadmium yellow mixed with a little aureolin to cool it down. This evoked the overall colour of the view and the verbascum itself.

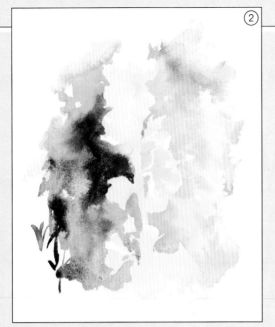

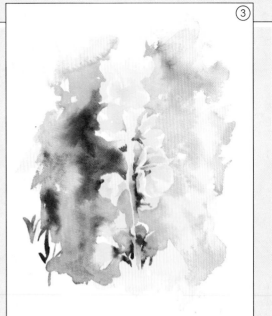

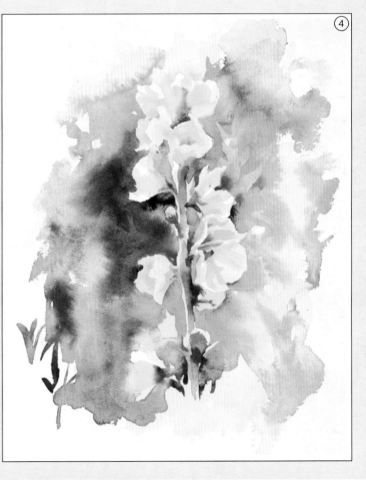

2 The next stage was to lay further washes to bring in the other colours discernible in the background, leaving the verbascum out of the washes. Here, Hazel has just begun to put some definition into the flower that will be her focal point.

3 The verbascum is now painted with more definition, though in places the petals have been allowed to bleed into the background wash.

4 Using a No. 5 brush, Hazel strengthened the individual flowers but reserved some white paper to give shimmer along the tops of the petals.

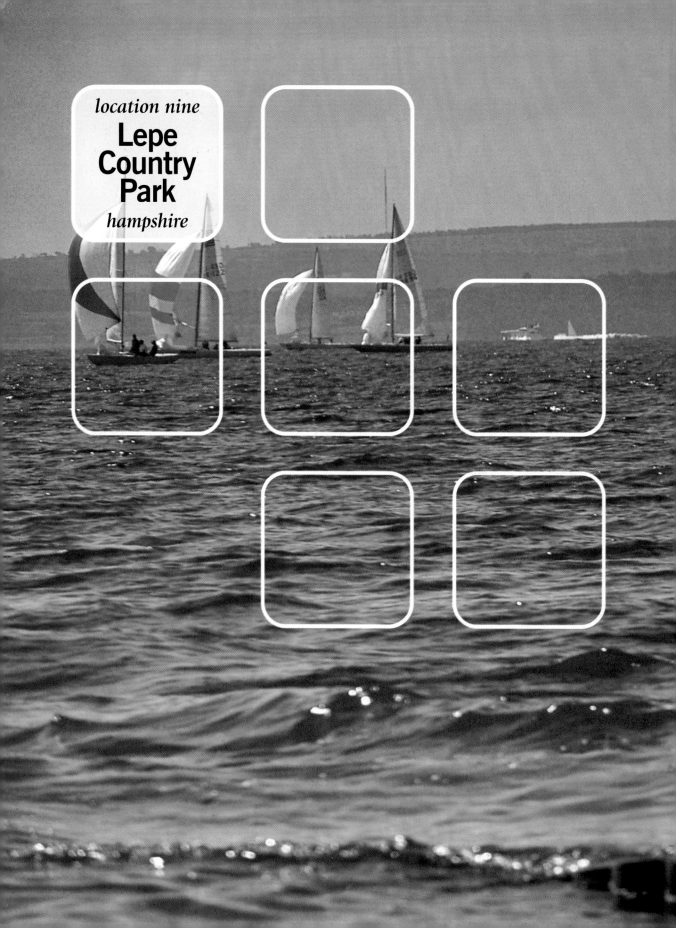

location nine
Lepe
Country
Park
hampshire

Today a peaceful place of recreation where visitors can enjoy swimming, walking, birdwatching and fishing, Lepe played a notable part in the Second World War. During the preparation for the D-Day landings in 1944, troops were marshalled along the coast of Hampshire and hundreds of soldiers with their equipment and vehicles were hidden along the narrow roads and woods in the area, with even the local people unaware of their existence. Twenty-one army huts were erected above the cliffs, where anti-aircraft guns kept watch for enemy aeroplanes and the V-1 flying bombs known as doodlebugs.

Most importantly of all, Lepe was used as a site for the building of floating harbours, known as Mulberry Harbours. It was expected that once the D-Day invasion took place the retreating German army would destroy all harbours so that the British Army would be unable to receive supplies, thus causing the invasion to fail. The solution that was found involved the construction of a floating harbour that was manufactured in parts at various places along the south coast. At Lepe, 700 men, working at top speed and under conditions of utmost secrecy, built six Phoenix concrete caissons – effectively boxes – measuring 62 metres (203 feet) long, 13.4 metres (44 feet) wide and 10.6 metres (35 feet) high. Once completed, they were winched along the beach and launched at high tide to join others made elsewhere along the coast. From there they were towed to Normandy where, within twenty-one days of the D-Day landings, they formed a harbour the size of Dover, capable of handling 12,000 tons of stores and 2,500 vehicles a day. The remains of the slipways that were used to launch the caissons can still be seen, as can the four-legged structures that formed part of the pierheads used for ships and landing craft.

The craft that take to the Solent today are of a very different nature. Cowes, on the Isle of Wight across the water from Lepe, is one of the most famous yachting centres in the world and the home of the Royal Yacht Squadron, one of the sport's most prestigious clubs. Cowes Week, held in early August, is not only a major international sporting event but is also renowned for a social scene that has traditionally included British and European royalty. A thousand boats take part in the races, and with starts from the Royal Yacht Squadron line at regular intervals, the water of the Solent at times becomes nearly obliterated by the sails of the competitors as they strive to make the best use of every puff of wind.

The Watercolour Challenge contestants were given a spot on the cliff edge, right by an anchor commemorating Lepe's place in the war effort. The challenge for the day would be to pick out a design from the jumble of all those sails that would make a strong and interesting composition. With a subject that was constantly in motion, some nifty sketchbook work was called for.

Hilary Guess

Dickon Armstrong

Frank Jacobs

Her use of bold line gave a sense of dramatic movement to Hilary's painting of the Solent during Cowes Week.

Hilary Guess

Hilary worked as an office sales administrator until she had her first child, when she gave up work and took up watercolour painting at the same time. Ten years later, she is an accomplished artist with four children of primary school age, whom she is teaching to paint. She is a member of the Moordown Artists Group and has taken part in several local exhibitions.

Hilary describes her style as vigorous, loose and colourful, and she likes modern painters who work with big splashes of colour and strong contrasts. At Lepe she did two preliminary sketches, one establishing tones with washes of neutral colour and the other a practice run for dry brushwork to show light on water. When it came to the real thing she used a barbecue stick dipped in Indian ink to draw in the boats, which was a bold move as the ink is indelible and it would not be possible to disguise any errors. It worked well, giving a strong sense of movement that made for a convincing boat race.

Dickon Armstrong

At fourteen years old, Dickon was the youngest contestant ever to appear on *Watercolour Challenge*. He has been painting in watercolour for two years and enjoys the extensive palette that is available compared to that of acrylics. Trains, harbours and portraits are his favourite subjects, and he hopes to become a famous train artist.

(bottom) Dickon wanted to place something of interest in every part of his painting, so he added a hot-air balloon and gulls from his sketchbook.

Dickon was the only contestant who chose to paint the anchor in the foreground. He decided that it needed a bit more interest, so he borrowed a gull from his sketchbook and added a couple more in the sky above to give further visual detail. He felt the sky to the left of the picture was rather blank compared to all the action taking place on the water so he put in a hot-air balloon, painting it red to attract the eye. The highlights in the water were scratched out with the tip of a scalpel, and further textural interest was given by the use of a pastel pencil on the grass in the foreground.

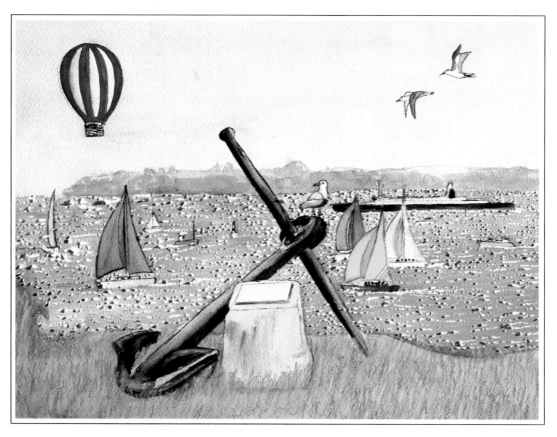

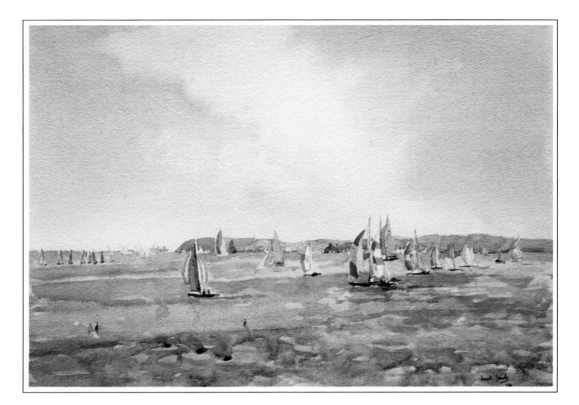

Frank's traditional watercolour shows his knowledge of the subject and has a real feeling of recession through the boats back to the Isle of Wight.

Frank Jacobs

Frank was an RAF pilot for twenty years before becoming a teacher and subsequently a schools inspector. Twenty-three years ago his school caretaker wanted to start a painting club and Frank tried watercolour for the first time. He has been painting ever since, and retired a little early so that he could make the most of his talent. He is currently chairman of the Isle of Wight Art Club.

As he describes himself as a marine painter and has been involved in organizing Cowes Week in the past, Frank found himself in an ideal location in which to compete. After doing a few sketches that would act as a reminder of the light and tide at his starting point, he put a boat in the golden section of his picture and worked his way out from there. The clouds in his sky made a reverse diagonal movement through the picture, and he used bands of light and dark in the sea to prevent the diagonal line of the boats from splitting the sea into two almost equal proportions. Accents of colour and light on the boats and water provided a fresh and lively painting done in a traditional style.

THE EXPERT APPROACH

The team arrived at Lepe to find a view of glittering blue water with the Isle of Wight beyond it and all signs of a hot and sunny day to come. At 8 o'clock, as the umbrellas were being put up, the scene was a peaceful one of empty water save for the huge dark bulk of a tanker making its way laboriously to Southampton Docks. On land, a few early-morning dog-walkers looked with mild curiosity at the activity around the vehicles and umbrellas but other than that the *Watercolour Challenge* crew and contestants had the place to themselves.

By 10 o'clock, things couldn't have been more different. The sea in front teemed with yachts, many of them with brightly coloured spinnakers hoisted to make the most of the gentle breeze, and behind the contestants the open patch of land was filling up with people, many of them equipped with binoculars to watch the racing and others just bent on a sunny day on the beach.

Susan Webb had managed to find herself a quiet spot and was finishing the first of three sketches. 'My theme for the three different approaches I'm taking today is that of the importance of experimenting and staying in touch with your emotional response to the view,' she explained. 'When you have gained some experience with watercolours there can be a danger of technique overtaking the painting. I have seen that happen among the *Watercolour Challenge* competitors from time to time. If they come armed with special techniques it can give them confidence which can be a great help, but it can also limit their ability to respond to the scene presented to them on the day. You have to allow space for things to flow, otherwise technique will stop you being sensitive to the subject.

'This first painting was started on a damp piece of paper, washed in mainly where sky and water were going to be, keeping a lot of light through both sky and water. I gradually built up the tones and shapes within the water, using broad sweeps of the brush. Because I hadn't drawn them first I started with very pale pigment so that I could change my mind later. I then gradually built it up layer upon layer, using a lot of ochre within it to keep the light dancing on the top of the water. As a wave tilts up towards the light it always becomes quite ochre in colour – it's never white except for the foam, but there's a lot of warmth and lightness in it.

'I used a bit of cobalt blue in the sea, but I worked a lot more green into it because as the waves turn over you often get this greeny tinge coming through. That was just the dirty green from the bottom of my palette. Where the green got a bit too heavy I used a little bit of light red or mauve running through it very slightly to modify the green, giving it different tones. Then I painted in the boats, lightly washing them in. At the end I just took a craft knife blade and scraped a little paint off to give a feeling of foam flecking up from the boats and on the waves. I'm happy with the balance of that painting, so I'll leave it there. Also, it's time to talk to

(right) The tide was right in as Susan did her first painting. The boats came by so close that she decided to take a viewpoint as if she too were on the water.

(below) Detail: Using yellow ochre, green and blue with a little light red or mauve to modify the greens, Susan created the effect of rolling waves through the water. Highlights were scraped out with a knife.

Hannah about the challenge the contestants face and not long after that I'll be giving them some comments about the way their paintings are going so far.'

As ever, the crew had a hasty lunch, this time in a restaurant down on the beach. The other customers were in an eating ice-cream, wearing flipflops, bouncing beach balls kind of mood, and although the crew were working as hard as usual the atmosphere did become a good deal more relaxed than it is when they are on an exposed hillside with a biting wind round their ears and rain slanting down under the umbrellas. As they hurried back to their position up on the low cliff, Susan set up a chair on the beach and began a second painting. It didn't take her long, and she just had time to explain how she had done it before she had to leave to film the tip of the day.

'The shingle spit is just starting to appear, so I decided to paint the figures in silhouette on the spit against all the boats on the Solent,' she said. 'I started with a damp piece of paper – not quite as damp as the last one, but I wanted soft edges so that I would get the impression of distance without having to paint very much. There's a feeling of the Isle of Wight in the background, but it's not at all defined and because there isn't much detail in the background I didn't have to put much into the foreground either. I made a pattern of the boats on the water that

complements the pattern of the sand and spit and moves the eye around. Then I just put in a couple of figures in silhouette and that was that. It made a nice, simple composition representational of the view. I didn't feel it needed to have anything more added to it.'

By the time Susan returned the boats had gone home. As she was seven months pregnant she was now beginning to feel tired, so she chose a different approach for her third painting. 'Here I've responded more to the colour and texture of the shingle spit, though I have made it look sandier than it is,' she said. 'I wanted the dancing play of light on the water picked up through the sand, with the dirty, muddy texture in the front. What was so nice here was the contrast of the tiny figures with the huge piece of sand and stretch of water behind.

Dampening the paper with clean water before she laid in any colour gave Susan's second painting a soft, diffused feel.

'I began with a dry piece of paper and took a big wash brush loaded with plenty of paint. Using a mix of French ultramarine with monestial green and sap green, I washed in the dark parts of the water, making a pattern and allowing the accidental effects of texture to happen by brushing very lightly so that the paint was allowed only to catch on the raised surface of the paper. That made the top shape of water, then, because I wanted to subdivide the sand shape again, I made a second shape of water coming in as a second pool. I didn't want that shape to stand out quite so much, so I took some washes of yellow ochre, burnt sienna, light red and alizarin crimson and French ultramarine mixed together, which made a purplish colour. I laid on the basic washes for the dark area of the sand, again using the technique of catching the surface of the paper.

'I let that dry then did more work on the beach. I didn't want to have any sharp lines on it, but I had to have the tone right so I worked that up a bit, laying one wash on top of another. Then I went back to the water, which had a lot of sparkling white through it. Although it was very effective it was rather crude, because it took your eye up to the water. My focal point was going to be the woman and the dog, so I didn't want the viewer looking at the water first. To solve this I took a wash of monestial blue back over the water, again letting it just drag over the surface so that it hit in some places and not others. That washed down the light in the water so that it was blue. Then I decided to keep a little light coming through, so I took my tissue and dabbed off some of the blue before it was dry. The result is that in the water there is the green wash, the white that has the blue wash over it and the area where most of the blue wash has been lifted off. This gives several tones of dancing light through the water without it actually being bright white and taking away from the focal point.

(right) In a more abstract approach, it was vital that shapes and proportions were interesting as there was little else to engage the viewer's eye.

(below) Detail: Rather than using detail to make the sand come forward from the strong colour of the water, Susan strengthened the colour of the sand with cadmium yellow.

'Because the colour of the sea was quite strong, I increased the colour on the light part of the sand by using some cadmium yellow with the yellow ochre. Again I dragged with the brush so there is a sense of the texture of the sand not being completely smooth, though it isn't as obvious as the sea.

'I did a sketch of the woman and the dog before I began the painting but I didn't draw on my paper, so as I was washing the paint on I was very conscious of the shapes that I was making. It was very important that each shape worked in a purely abstract manner, whereas in the other two paintings the proportions didn't matter so much because they were representational. In this painting I had nothing else to rely on, so it had to have really interesting shapes and proportions and I was very careful and slow about where I put the paint – though of course when you are putting a wet wash down on dry paper you have to be fairly quick with your hand or you will get hard lines on it. In this painting I was careful with my mind and quick with my hand, whereas in the first two it was the other way round. Here the balance of the shapes had to be right because the only piece of form in this painting is the woman and the dog. Everything else is amorphous.

'In the first picture atmosphere is all, and colour and texture are minimal. In the last one, colour and texture are what the picture is about. There is no atmosphere to make it feel three-dimensional. Here the pattern is very deliberate, so the emphasis is on the two-dimensional, more textural approach of the painting. I've responded to the same scene but from a different mood, so the paintings are quite different in style.'

technique

THE TURNERESQUE TECHNIQUE

Although the style of painting known as the Turneresque technique is associated with contemporary work, it was first practised by Joseph Mallord William Turner (1775–1851) more than 150 years ago. It is typified by loose washes of soft, diffuse colours in the background contrasting with a simple form in the middle distance or foreground which is presented as a silhouette. Also known as 'blottesque', a term coined by the art critic and social theorist John Ruskin, the style of allowing loose washes to run through and over each other on wet paper to give an impression of the scene rather than a realistic depiction of it was revolutionary in its day.

To work with these diffuse, wet washes you will need large brushes and plenty of tissues. Begin by wetting the paper thoroughly and then lay bold washes of soft colours, dabbing off excess paint and altering the angle of the easel as necessary to allow the paint to run

down the paper. Wipe out light areas with a piece of tissue or, if you are not confident that you can control a tissue well enough, a cotton bud instead.

Because your middle distance or foreground forms are illuminated from behind, no light or dark tones will be visible in them. Paint them simply, silhouetting them against the light but keeping a close tonal range so that they do not unbalance the picture.

(above) As a background for all the four pictures shown here, Susan used washes of cadmium orange, cadmium yellow, cadmium red, yellow ochre, alizarin crimson and ultramarine, wiping out the sun and the light on the water beneath it with a tissue.

(right) This picture shows a more contemporary use of the Turneresque technique in that the colour is stronger. After painting the background, Susan used some sponge and tissue to lift out the diagonal movement in the sky from top left down to bottom right. The ripples around the boat were painted with a little white gouache mixed with lemon yellow, while those in the foreground are white and alizarin crimson. A few touches of gouache also appear in the rigging.

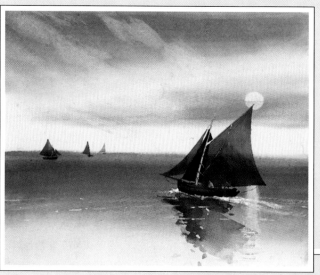

(above) Here Susan sponged out the diagonal sweep in the sky and then dragged more paint across the top of it, applying some purple with a dry brush and some slightly wetter yellow-orange. Extra purple and lemon yellow washes were floated on to the water, the yellow combining with the blue that was already there to make green. A little white gouache with yellow-orange made an exaggerated reflection of the sun. Susan then drew in the boat and painted it in with watercolour, partially lifting it off to give a misty atmosphere. This painting more closely approaches the romanticism of Turner, but the colour is still exaggerated and contemporary.

(right) In this version, the tones are closer and the boat is so wiped out that its form is barely distinguishable from the sea. The colours are quieter and a grey wash has been floated across the sky to give it more depth. Grey with green and purple was washed over the sea to create the mist hanging over it.

(left) This painting was also begun with quiet colours, but using a lot of dry brushwork and some white gouache mixed with the paint. In the foreground waves the gouache is so thick that it stands up off the paper, but because the tone is very close to the tone of the washes beneath it sinks back and merely gives a three-dimensional feel. The gouache has been applied more thinly further back in the picture and, coupled with the diagonal movement of the boat, pulls the eye into the composition. The boats are put in with a mid-tone and are little more than silhouettes, so rather than looking at their details the viewer sees instead the overall feeling of the picture.

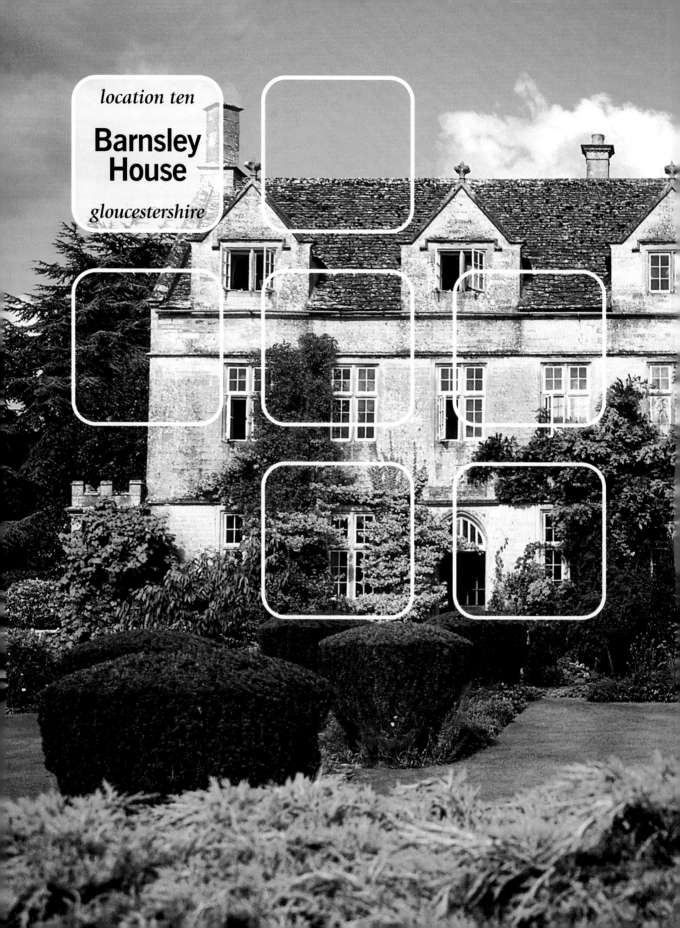

With its weathered Cotswold stone walls, sweeping lawn and stately trees, Barnsley House is the epitome of a traditional English country house, and it is no surprise that Americans place it high on their list if they are making garden tours during their visits to the UK. Built in 1697 by Brereton Bourchier, whose initials can be seen carved in stone above the garden door, the house became a rectory in 1762 and remained so until 1932. Generations of clerics made their mark on the house and garden, including most notably Charles Coxwell, who built the stone wall surrounding three sides of the garden in about 1770, and Richard Musgrave, a descendant of Brereton Bourchier. Brought up at Barnsley Park, a grander house also built by Bourchier on the other side of Barnsley village, Musgrave no doubt found his new home too small and in the late 1820s he added an extension to its north-eastern end.

Barnsley House gained fame for its garden in the latter half of the 20th century. Its creator, Rosemary Verey, first visited the house in 1939 when it was in the possession of Cecil and Linda Verey, who were to become her parents-in-law. In 1951 the elder Vereys made over the house to their son, David, and moved into the Close, an adjacent converted stable block. They retained a small area of garden for their own use, while Rosemary and David took charge of the 1.4 hectares (3½ acres) of land and, a decade later, began the transformation that gained it a place in dozens of gardening books, not least those written by Rosemary herself. She had begun to learn the basics of practical gardening during the war, when she rented a cottage in nearby Fairford while David was away in the armed forces, but on their move into Barnsley House still had no knowledge of design. However, as her passion for gardening grew she took advice from leading garden designers of the time, discovering the importance of pattern, form, colour and vistas.

One of the most notable and well-loved features of the garden is the 18th-century temple with a pool at its foot. The temple, originally built at Fairford Park, was a gift that arrived by lorry in 1962, each stone numbered for reassembly. It was exactly the same width as the pool that had been created eight years earlier, and sat perfectly within its new home. From it there is a long vista with a fountain at the end made by Simon Verity, who is responsible for many of the sculptures in the garden.

Every visitor to Barnsley House will find their own area of particular enchantment: perhaps the laburnum walk, the pleached limes, the broad border or the ornamental potager. Rosemary Verey, now herself considered one of Britain's foremost garden designers, moved into the Close in 1988 and the house and garden came into the care of her son Charles and his wife Denzil. Open to the public five days a week from the end of January until mid December, the garden receives nearly 18,000 visitors annually, a figure that testifies to the genius of its creator.

I n 1999 Felicity Hedley made four appearances on *Watercolour Challenge* as a competitor, and at Berkeley Castle in Gloucestershire on a hot and sunny day at the end of July she scooped the grand prize of a painting holiday in Cuba with Ken Howard as tutor. She returned to the set in August 2000 as judge for the day, with tales to tell about her experiences since winning the previous series.

'One of the nicest things about entering *Watercolour Challenge* was that I didn't have a lot of time to think about it,' she says. 'My interview in Dorchester for the Dorset week was just days before filming was due to start, so it was very spontaneous. I don't remember having any feeling of nervousness about it and each day I won I was thrilled, but I suppose I hadn't really thought it through. It was such a surprise to win the final and even now, a year later, I still can't believe that I've done it and I've won it and I've been to Cuba.'

(left) Felicity Hedley, winner of the 1999 series of *Watercolour Challenge* and judge of the art experts' competition in the year 2000.

(below) *Guantanamara* mixed media

Felicity flew to Cuba in the early spring of 2000. She found it overwhelming at first because there was so much she wanted to paint, so she took a couple of days to soak up the atmosphere. 'I kept walking round backstreets and down alleyways in Havana and everywhere I went I could hear music, so I wanted to put that in some of my paintings. I decided the best way was to paint quickly on street corners so that I could be in the thick of it. My style of work is quick and messy, with inks and acrylics as well as watercolours, and it was well suited to the surroundings because a lot of the buildings are deteriorating under layers and layers of paintwork, which I found so attractive, if rather sad.

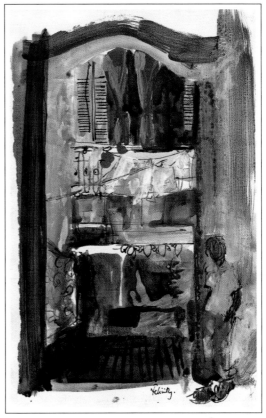

(above) *The Blues*
mixed media

(above right)
Behind the Doors
mixed media

'I had a two-week exhibition of my Cuban pictures and also some British landscapes as part of Dorset Art Weeks in May. The exhibition was at the Peter Hedley Gallery at Wareham and it went very well, but it was a real eye-opener for me. I hadn't realized how much work was involved, and I learnt a lot very quickly.'

Felicity is looking forward to learning, experimenting and remaining open to inspiration. 'I see my landscapes getting much larger,' she says. 'There's a lot I want to do connected with space and letting one's imagination go, and I've recently moved close to the sea to give me that sense of spaciousness. I'm fascinated by water and I would love to have an exhibition of huge canvases about water or big skies. When I'm in the middle of a painting I feel a sensation that's really hard to explain, but I just know that this is what I'm supposed to be doing. It's like being given a second chance in life; I've started this relatively late, yet things are happening very fast.

'I really enjoyed coming back to *Watercolour Challenge* and it was so interesting to watch three professional artists working – they were so confident in their approach, right from their first brushstrokes. I love the fact that the programme is for people of all different ages and types, and for as long as it's like that I think it will remain interesting to the viewers.'

As Jenny Wheatley, Mike Chaplin and Hazel Soan arrived at Barnsley House to take part in the art experts' competition, there was a distinctly holiday air among contestants and crew alike. While the competitive element is never cut-and-thrust on *Watercolour Challenge*, there was an especial air of camaraderie among the artists and, of course, an already relaxed working relationship with the crew. These artists had plenty of experience of the filming process, and it was going to take more than a camera to make them nervous.

Even if there had been tension, the atmosphere at Barnsley House would soon have dispelled it. As the umbrellas were set up in the freshness of early morning the garden sparkled with dew that was soon burnt off by the sun, and the fragrance that wafted from the borders on the warm air brought with it a sense of relaxed and luxurious enjoyment.

The art experts were allowed one privilege not given to other contestants: they were taken to the location the night before so that they could choose the view they wanted to paint. With Jenny facing the 18th-century Tuscan temple, Mike positioned at the bottom of the yew-flanked path leading to the

(above) Jenny Wheatley, Mike Chaplin and Hazel Soan lining up to take part in the art experts' competition — but it doesn't look as if any of them is fired with the killer instinct!

(left) Jenny chose a view of the 18th-century Tuscan temple, attracted by its theatrical quality.

house and Hazel placing her easel within arm's reach of a mass of Japanese anemones, filming – and painting – could get under way.

After using gumstrip to make a square format for her painting, Jenny began by laying on washes of blue with a very broad brush. 'At the moment I haven't got any drawing on here at all and I'm just beginning to establish some of the colours and tones that lie underneath the painting', she said, 'but they will change dramatically as I go along, so I am sort of beginning to draw. I will make a few marks right across the paper, but a lot will change. I shall keep my options open as long as possible, just as I've been advising contestants to do throughout the series.

'Although what is on the paper looks very arbitrary at the moment, it's really important to me that I get textures and hard edges right from this early stage. I've just dribbled some paint from a great height, so that along with some of the straight lines and the scratched marks I have got some of this imposed texture and splatter from a distance. I'm now going to throw some paint across from a cup instead of dribbling it, and tilt the board – I work with it flat rather than on an easel a lot of the time so that I can move it easily when I like.

'I've already begun to establish where the structure is and where some parts are receding. This is now very wet and I can't dribble anything else on until it has dried out a bit, so I'm going to take a toilet roll and lay it across to take off the surface water. I'll use a printing roller on the toilet paper to help soak up the paint and also to create a texture. The little paler passage at the back will be the white of the seats. I want everything to lead into that area, but I don't want it to be too obvious.'

On Jenny's table stood an array of pots containing powdered pigment of intense colour. While she does use ready-made paints, she also chooses to make her own if that best suits the painting she is working on.

(above) The early stages of Jenny's painting. Pigment has been applied in broad washes with large brushes and also dropped onto the paper from a cup, then encouraged to run in the desired direction by tipping the board.

(right) For this painting, Jenny decided to make her own colours from pure pigments to give her more textural options.

'I have here a mixture of gum arabic, a little water and glycerine,' she explained. 'Gum arabic and glycerine make a binder that keeps the paint on the paper, and preparing the paint is just a matter of choosing how much gum arabic to mix with the pigment to make a thicker, thinner, more translucent or more opaque colour. When I'm working on this scale and in this way I make my own paint, as I find

(left) By mixing her own pigments, Jenny was able to achieve heavily granulated textures that are not possible with ready-made paints.

I can get some lovely glowing colour underneath and thick colour that can be scraped and scored into, so it gives you more possibilities.

'When I'm mixing paints as wet as this I make solutions in a cup. I can then gauge how thick the content is by swirling it round to see how it sticks against the sides. It lets me judge how intense the colour is and therefore how much will be left on the paper when it dries, and I can also tell whether the colour is exactly what I want or if I should be adding in another.'

While Jenny began with glowing colour, Mike's approach could not have been more different: a preliminary tonal sketch done on a slightly crumpled

(below left) Mike's view looking up the path towards the house called for a vertical composition.

(below) Mike's starting point was a sketch done with felt-tip pen on kitchen towel. Some coffee spilt on the table came in handy for a rough colour note.

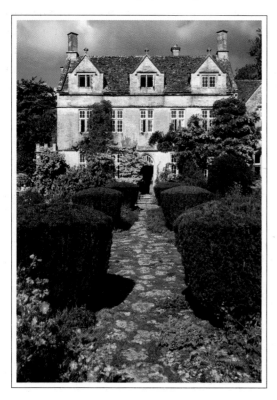

(right) With his kitchen-towel sketch clipped to the board for reference, Mike began laying in washes of warm colour where the house and path were to be.

piece of absorbent paper. 'I wanted to begin drawing while the crew were setting up and this was all I had to hand, or rather in my pocket – a felt-tip pen and a bit of kitchen towel!' he said. 'It's a beautiful garden and what to choose is the problem because there is so much here. I've been wondering whether to do a view, an impression or a bit of both. Most gardens offer horizontal subject matter but I'm going to work vertically straight up the path in a very formal, symmetrical composition. I'm hoping that strong tone will throw the symmetry aside if I get a lot of light on one side of the painting and a lot of dark on the other, which will mean I've got a symmetrical linear composition but an asymmetrical tonal one. I think it'll be mainly a tonal composition rather than a colour one, as I'm most interested in capturing the light today. I may reserve one or two bits of blank paper for these brilliant orange flowers in the foreground and the pink of the mallow either side of the path, though.'

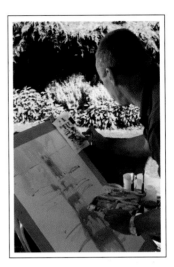

Shortly after he said this some coffee was spilt on the kitchen towel, causing him to adjust his preliminary ideas. 'The coffee was a mistake, but I brushed it across as it's a help to see some colour on the sketch – it gives a clue that it needs a bit of coolness at the back. It has prompted me to think about the warm colour in the foreground. It's much stronger on the towel than it is on the path, but I think I might go for that strength of colour. I've also changed my mind about the light and decided to work into it, although it's right behind me. I drew the top half of the composition and the shapes of the yews looking towards the

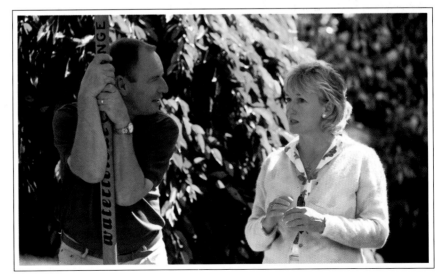

Mike takes time off from painting to chat with Jill Robinson in the leisurely atmosphere of the art experts' day.

house, but to put the tone on I walked down and looked back up the path to see the light as it will probably be at the end of the day. With such a simple, symmetrical composition it needs a very dramatic tonal statement and strong construction to make it work, otherwise it will be very flat. Using the light that way makes the sculptural shapes of the yews come out, whereas looking towards the house they are

rather amorphous and flat with the light behind me. I'm ready to start on the painting now, but I don't think it'll ever be as fresh as that quick first drawing.'

Followed closely by cameraman Rob Sargent, Hazel had done a couple of colour sketches of different areas of the borders. 'There are dozens of potential subjects here, so my choice would have been to paint several in the course of the morning or the afternoon,' she said. 'However, I'm not allowed to do that today, so I've put my hat, my colour sketches and my paintbox on this table in front of me and I'm painting them with the Japanese anemones behind them, so in a way it's a story of my own experience of the garden. There is so much here that I love, but although there are lots of areas where there are large individual flowers this is one of the few areas where there is a whole mass of flowers of similar colour. This lovely contrast of the yellow centres with the mauvey-pinky colour of the petals really appealed to me. I'm not a lover of the long-distance view – I prefer to get in close to the subject.

'I like to kill off most of the white paper that doesn't need to stay white early on in the painting, because otherwise you can't get the tonal balance right, particularly on a bright day like this. I go in with broad washes and find an underlying colour that's common to several parts of the painting or even the

(above) Before she began her main painting, Hazel did some quick colour sketches of various flowers in the borders to use in her composition, closely watched by Rob Sargent's camera.

(below left) Hazel's choice of subject was a bank of Japanese anemones with her hat, her sketches and her paintbox on a table in front of them.

(below) Hazel's starting point was a yellow ochre wash over the table and hat, after which she started to put in the flowers and foliage. The same colours used in that area are also beginning to appear in the sketchbook and paintbox in the composition.

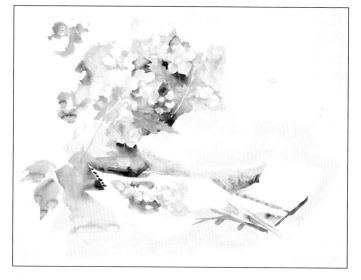

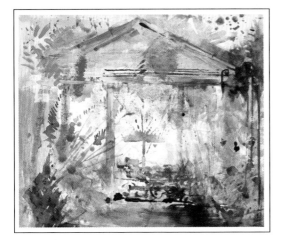

(above) Applying paint in a variety of ways, from broad or fine brushstrokes to dribbling it on or using her fingers, Jenny built up a densely layered painting.

whole painting, in this case the yellow ochre of the hat that runs through into the leaves, the table and any of the dark areas. That for me is a perfect base colour and it's warm like the sunshine. I can't use it where the flowers are, though, because it would make them rather grey. As for their beautiful delicate pink or mauve – I can't decide which it is and I'm toying between permanent rose and rose madder to try to find the colour. However, the challenge for me today is painting throughout the changing light, which I don't usually do.'

As the morning drew to a close, Jenny's painting was progressing at a dramatic pace. 'At this point I'm still building up and it still must look incredibly arbitrary, but it's very important that I've got the directions of the marks coming in towards the seats,' she said. 'I've been holding the paper up to dribble paint down and using my fingers to pour paint into it. The next thing to do is to try to soften off the roof, so I'm going to crumble it a bit. I love the texture the pigment itself gives, and it allows you to get the three-dimensional element all the way from being really thin and glazed, as ready-made watercolour would be, right up to being much more impasto. Later I'll put pigment on thickly in areas where I can scratch back into colours below. I might even crumble some pigment on while it's wet and roll it in to give a bit more texture.'

Mike was also using his own pigments, which he had ground in his studio with a pestle and mortar. 'I'm trying to introduce the dark drama of the tones in

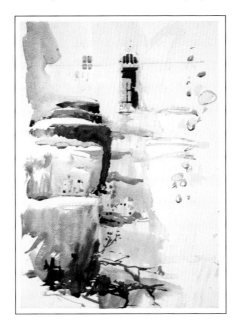

(right) Mike's painting is now taking shape, with the tonal drama of the clipped yews on the left of the composition.

the painting while keeping the colour fresh. I'm not looking for mud; I want strong, vibrant colours that hint at very dark tones,' he said. 'Pigments ground by hand are much coarser, and by grinding less or more I can control how much they granulate. Here the shapes are large and flat, so introducing granulation gives textural interest. I'm starting to suggest a bit of linear structure now, trying to balance line against tone and colour.

'I'd envisaged the painting being darker and indeed I can still go darker, but I'm not sure I want to lose that quality of colour so I have to make a decision fairly soon as to

whether it's going to be about colour or tone. It's quite good to be stopped by the crew because it makes you stand back and think about what's going on.

'We all assume we have likes and dislikes about the subjects we tend to go for and I'd normally steer clear of gardens, but the moment you start painting the problems are all the same: balancing light, colour and tone, the direction you have set yourself and how much you are prepared to depart from that. The moment you touch the paper the problem of the subject disappears, because it's all about the joy of painting – and it's very much the joy of watercolour that you go in a new direction that presents itself, whereas with oils you have more control.'

Hazel said, 'I thought I wouldn't like the change of light, but sitting here painting this I'm so enjoying myself I don't mind what the light does. I love flowers because they are an excuse for colours you might not often use liberally. I hardly did any drawing first because I find if I draw too much I lose some of the eye with which I paint.

'In painting the anemones I dashed yellow in the centres while the mauve colour was still damp so that the stamens crept out into the petals. Some flowers are blurred while others have crisp edges; I don't want it to be too definite, but anemones are crisp-edged flowers. Now I've started putting in greens and

An artist in her element: Hazel Soan painting a favourite subject in one of the most beautiful gardens in England. Here she is putting in the details of the paintbox with mixes of the few colours used in the painting.

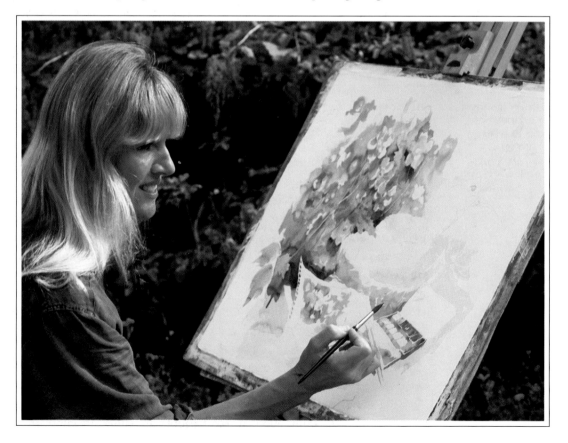

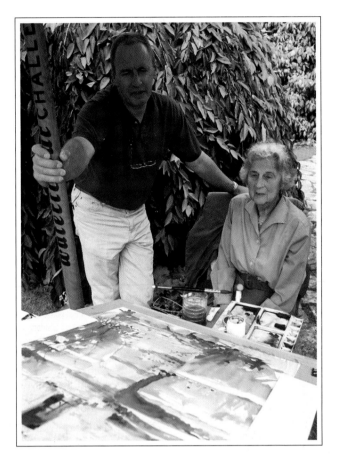

Rosemary Verey, creator of the garden, takes a close look at Mike's painting and, as an artist in her own right, contributes some advice.

although I often make green from Prussian blue and a yellow, sap green was the perfect colour for the anemone leaves. It also gave me the chance to let it blend in and out of the mauves without having to worry about time spent mixing blue and yellow together, though I have occasionally dropped in a bit of Prussian blue and mauve wet-into-wet for the depths between the flowers. I shall paint the colours in the palette with colours already used in the painting, so, for example, the cadmium red in the palette will be painted with the pink and Indian yellow.'

After a cheery lunch in the local pub, the crew and artists got back to work as quickly as possible, conscious that the weather was slowly beginning to deteriorate. Each of the artists was joined briefly by Rosemary Verey, who came out to see exactly what was taking place in her famous garden. Mike's painting in particular caught her attention, and the two of them, each artists in their own right, tried placing yellow and orange flowers against his painting, moving them here and there in an experiment to see where splashes of bright colour should come.

As Jenny neared the end of her painting she explained, 'A lot of my family are involved in the theatre and I like to have the equivalent of layers of stage space in a painting. Found objects, ambiguity and having a little bit of architectural detail to hang it all on to are what appeal to me. I don't think the subject itself is important, it's the response to it that matters. The mystery and lyricism here intrigue me, the thought of the gossiping and the tales that have gone on between people sitting in the seats in the half-light of evening. I won't be painting any people in the seats, though, as I love the feeling of someone having just left or of something being unsaid. One of the last things I need to do here is darken the colour on the back wall of the temple so that the colour that's there now will look like the white of the seats.

'I feel my painting is a complete statement but also the beginning of a series, so that's a nice place to leave it.'

Mike's final thoughts were, 'I draw confidently but I'm not instinctive with colour – I have to think about it. Most people are either draughtsmen or

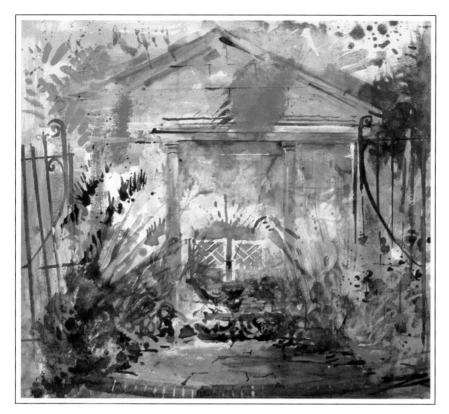

Jenny's final touch to her painting was to bring out the seats in the temple by darkening the wall behind them.

painters; few are both. My message to anyone who wants to be an artist is to have a go. It's the one subject where everyone can find success, because the only person you have to compete with is yourself, finding your own level at which you can be successful. Don't try to judge yourself in comparison to other artists. Just have your own vision and get as near to that as you can.'

Hazel, putting the final touches on her painting, said, 'I decided to paint something to do with *Watercolour Challenge* and our day, so I've put in my beloved hat that I can't wear for filming because it would shade my face, the paintbox to symbolize the pleasure I've had with the programme and the sketches that I did first. It is an autobiographical painting about my delight in the day here. It's also a way of saying to people that they can do anything with the subject they want to, and there's no need to go for the obvious view.

'I found the experience of being filmed while painting rather relaxing, because I was denied the freedom to paint in the normal way. There was a feeling of a lift of responsibility and of not being entirely in charge. That was very freeing and I have felt quite elated all day.'

In fact, the sense of elation was a shared one. As the easels were put away and the umbrellas taken down, a bottle of champagne was opened to celebrate a day in which three skilled artists had in their individual way communicated their response to such a glorious setting.

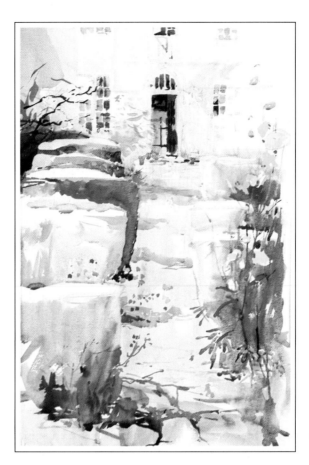

(left) Mike's finished painting, with dabs of paint in the yellow evening primroses applied straight from the tube by Rosemary Verey.

(below) Hazel's painting was an evocation of her day and also of her time spent as art expert on the third *Watercolour Challenge* series.

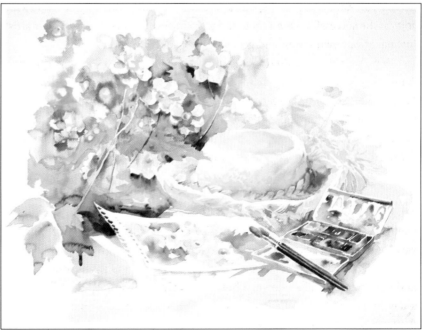

Index